David Curtis
Light and Mood in Watercolour

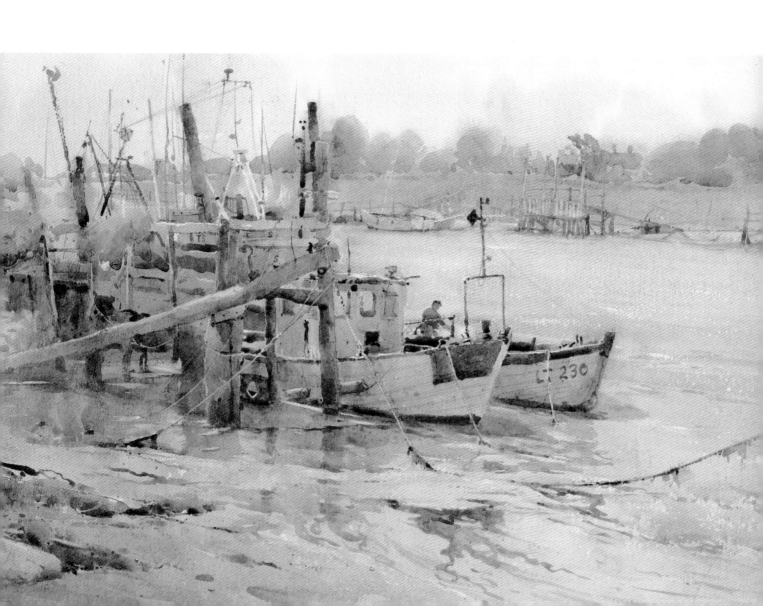

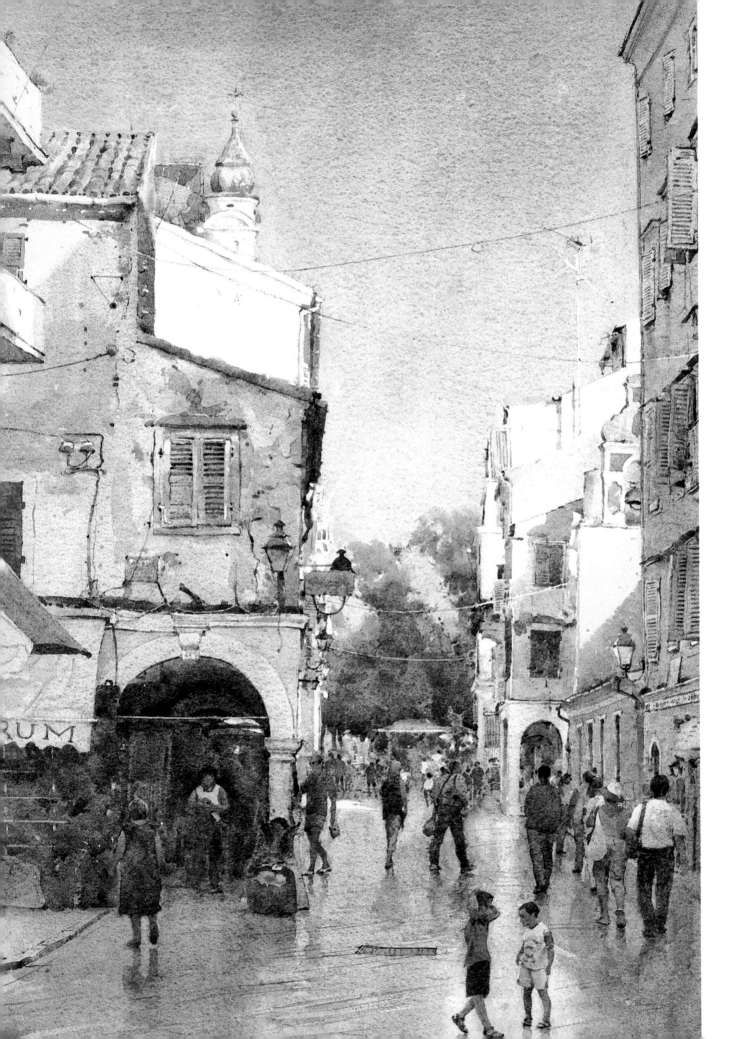

David Curtis
Light and Mood in Watercolour

David Curtis

with **Robin Capon**

Corfu Old Town
57 x 39cm (22½ x 15¼in)

BATSFORD

To my family, friends and painting companions

Acknowledgements

I would like to thank Robin Capon for all his patient hard work on the text. It has been a pleasure to collaborate with him. My thanks also to Steve Bennington for his skill and understanding of the painter's needs in terms of good colour photography; Dr Sally Bulgin for the foreword; and Richard Hagen for the loan of transparencies.

www.djcurtis.co.uk
david@djcurtis.co.uk

First published in the United Kingdom in 2005 by
Batsford
151 Freston Road
London W10 6TH

An imprint of Anova Books Company Ltd

Copyright © Batsford
Text © David Curtis and Robin Capon
Illustrations © David Curtis

The moral rights of the authors have been asserted.

ISBN-13: 9 780713 489552
ISBN-10: 0 7134 8955 3

A CIP catalogue record for this book is available from the British Library.

10 9 8 7 6 5 4 3

Reproduction by Classicscan, Singapore
Printed and bound by Craft Print International Ltd, Singapore

This book can be ordered direct from the publisher at the website: www.anovabooks.com, or try your local bookshop

Distributed in the United States and Canada by Sterling Publishing Co., 387 Park Avenue South, New York, NY 10016, USA

Contents

Foreword

I was delighted and honoured to be asked to contribute a foreword to David Curtis's new book on *Light and Mood in Watercolour*, because I have been an admirer of the man and his painting since first meeting and interviewing him for the chapter on his work in my *Oils Masterclass* (HarperCollins) in 1995. Since then he has contributed articles to the magazines *Leisure Painter and The Artist*, illuminating his approach to painting and generously sharing his thoughts and providing advice and inspiration to many thousands of painters throughout the world. He is an inspiration not only because of his ability to capture the spirit of a place with its transient light effects and different weather conditions, but also for his enthusiasm and his willingness to share his experiences in the straight-forward, down-to-earth way that is characteristic of his Yorkshire upbringing.

David has the eye and the skill to extract the magic from a subject by plucking out the essentials he needs in the few hours he has in front of a scene. As a committed *plein-air* painter he edits detail, simplifies the complex and vital elements of a composition, and demonstrates that what matters in painting is as much about what you leave out as what you include.

He has accomplished a great deal and is now recognized as one of Britain's leading figurative painters in oil and watercolour. The reproductions of his watercolours throughout this book will be an inspiration, and the no-nonsense text will inform and explain in illuminating detail the thinking processes and working methods behind these stunning paintings.

Sally Bulgin
Publishing Editor of *The Artist* and Publisher of *Leisure Painter*

Introduction

Seldom does a day go by when I do not have the desire to paint. My love of painting began when I was about twelve, and from then on I have never doubted that the greatest satisfaction I could achieve in life would be from using it to express the delight and inspiration I find in many different kinds of subject matter, especially landscape and marine scenes.

I did not go to art school – in fact, I trained in engineering and design. But this taught me the value of drawing skills, which is something I probably would not have experienced at art school at that time. So, in effect, I am a self-taught painter, although naturally I have been inspired and influenced by the work of other artists. In my case the influences have come principally from the British Impressionist painters of the late 19th and early 20th centuries – notably those of the Staithes School, such as Laura Knight, Mark Senior and Fred Jackson, and the Newlyn School, especially Stanhope Forbes and S J 'Lamorna' Birch. Incidentally, I also much admire the music of the British composers of that period, because their work was very descriptive and for me it evokes a similar atmosphere and response.

Painters need lots of self-belief and perseverance. If there is one piece of advice that I would offer inexperienced painters, it is that they must be prepared to work hard to learn their craft. In my view, there is no substitute for developing observation skills and the ability to draw, nor for appreciating the value of sound composition and the need to understand and respect the chosen painting medium. In learning to paint you will glean information, advice and ideas from a variety of sources, gradually discovering and developing your own style. It is important to be true to yourself as well as the medium, rather than simply cloning someone else's method of painting. But be patient; it does take time!

David Curtis in his studio
David Curtis painting outdoors

Many artists enjoy sharing their knowledge with others, and one of the best ways to learn about painting is to work alongside an experienced artist. When I was young I often painted with an accomplished local artist, Andy Espin-Hempsall, who worked in the traditional manner known as *plein air* ('open air' – that is, outdoors, in front of the subject being painted). Later, I was fortunate enough to paint with Edward Wesson, Jack Merriott and other well-known artists of the time. In this book, as well as discussing in some detail my working methods and observations on watercolour painting, I have tried to create a sense of the process for the reader by including several step-by-step examples. I hope these will help demonstrate more clearly the way that I work when tackling different subjects, and in different situations.

I paint in both oils and watercolour. Essentially I am a *plein-air* painter and for me there is nothing more exhilarating than the challenge of capturing the special mood of a scene before its character is radically altered by the changing light or weather. Watercolour is a wonderful medium to use. It is perfect for exploiting the transitory and subtle atmospheric effects found in outdoor scenes; moreover, it encourages the necessary spontaneous, sensitive approach. Yet, if required, it also suits a more considered, controlled method of working in the studio, while for certain subjects a combination of both *plein air* and studio techniques will often work best.

A Shortcut to the Beach,
Cala San Vincenti, Mallorca

57 x 39cm (22½ x 15¼in)

I was particularly attracted to the way that the palms created a contrasting, umbrella effect above the focus of light in the centre of this subject, which I found away from the main tourist area.

A knowledge and experience of a variety of watercolour techniques is always an advantage. Painting is never simply a matter of following a set procedure. Each painting requires something different to fully express the particular quality of light and mood that initially inspired you. The way to gain experience is to experiment with every aspect – materials, techniques, colour and composition, subject matter, and so on. This is how I developed my skills, and why I have included such a wide range of topics in this book. I hope the information and illustrations that accompany these topics will prove helpful and encouraging in your adventures with watercolour. It is an endless, fascinating process!

The Old Harbour, St Ives, Cornwall
28.5 x 39cm (11¼ x 15¼in)

An interesting, sound composition is an essential quality to look for in a subject, I think, and this view included various directional lines that enhanced the basic design.

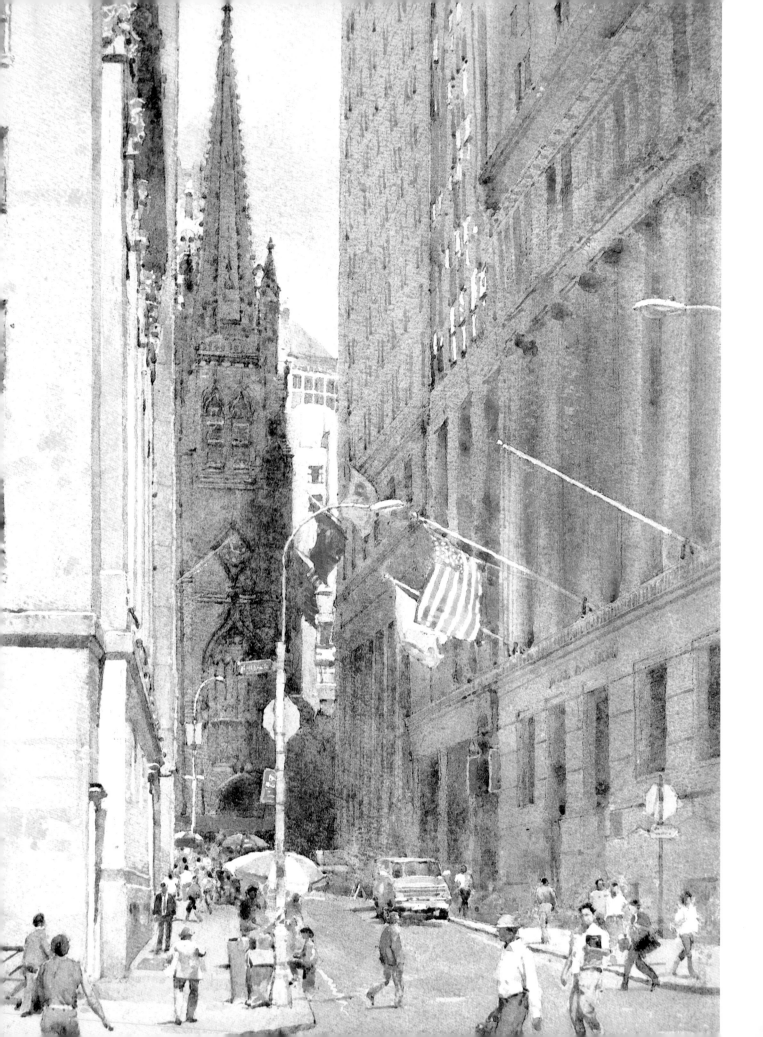

1 The Watercolour Medium

Many artists feel a natural attraction to and affinity for watercolour and I think this especially applies to landscape painters. With its immediacy, fluidity and, in many respects, versatility, watercolour is the ideal medium for capturing the transient effects of light and mood in the landscape as well as all that this implies in terms of subtle colouring and sensitive handling. Yet, while landscape remains the most popular genre for watercolour, there is also much potential for exciting work with other subject matter. For example, in addition to my marine and landscape subjects, I enjoy painting people, interiors and buildings in watercolour.

Perhaps the most intriguing aspect of watercolour is the fact that although everyone accepts that it is intensely difficult to use, it is nevertheless an extremely popular medium. I know from my own experience, which covers more than forty years, that watercolour can be one of the most frustrating ways of being creative known to mankind. But the challenge is part of the attraction, and as we gain in confidence and techniques, and are able to steel ourselves to be positive and expressive, then the results can be truly rewarding. The challenge I most relish is the *contre-jour* effect that can be found during the early morning and later afternoon on a bright, sunny day when there are strong contrasts of light and shadows. Success in capturing that fleeting effect never fails to create a real buzz!

The Ice-cream Seller, New York
39 x 28.5cm (15¼ x 11¼in)

Scope and characteristics

The most obvious characteristic of watercolour is that it is a very fluid medium, and consequently the principal painting technique relies on applying a succession of washes. Used with restraint, and especially when applied to white paper, these washes of colour will create immensely sensitive luminous and translucent effects which, for most artists, are further qualities that are synonymous with the medium. A limited use of colour and technique usually works best, so that the result is not overstated or overworked. Invariably paintings lose their vitality and impact if the colour is laboured to such an extent that it becomes 'muddy' and opaque.

This is not to say that there is only one method of painting with watercolour, this being the traditional wash-over-wash approach in which the highlights are left as white paper. Especially during the past fifty years, there are also artists who have decided that working exclusively with very fluid washes, as well as being extraordinarily difficult and inevitably involving an element of chance, places too much of a constraint on technique and effects. They argue that by

above *Hall Cross, Doncaster, Yorkshire*
28 x 33cm (11 x 13in)

In this painting of a street in my home town, the real subject is the light. I liked the blue-and-gold feel of this autumnal afternoon and the way that little accents of light enlivened a scene that was mostly in shadow.

right *A Side Street in Alcudia, Mallorca*
39 x 28.5cm (15¼ x 11¼in)

Don't be afraid to make use of the natural surface colour of the paper for the whites and highlights in a subject. For example, in this painting there is only the slightest hint of colour on the building in the centre – much of the paper has been left white.

D. J. CURTIS.

Morning, Sun Rising, Staithes, Yorkshire
39 x 57cm (15¼ x 22½in)

Light is a quality that always interests me. As here, with the contrast between the warm light in the upper parts of the subject and the cooler, reflected light in the beck, watercolour can be a wonderfully sensitive medium for capturing a fleeting mood or an atmospheric effect.

adding body colour (watercolour mixed with gouache or acrylic) they can gain more control over the work and broaden the scope of the medium. Additionally, of course, watercolour can be combined with many other painting media, such as pastel, water-soluble pencils or pen and ink, in a mixed-media approach.

The use of body colour in watercolour painting has always been controversial. Purists believe that watercolour should be fluid, spontaneous and transparent, while the not-so-purists will argue that essentially there is too much dependence on the 'happy accident', so why not add body colour to give greater reliability and creativity. Obviously this has to be a matter for each artist to decide.

For my own part, with the advantage of many years' experience, I hope that I can handle the medium well enough to express my ideas in a first 'hit'. I value those special qualities of fluidity and translucency that only watercolour can offer. My use of body colour (I actually use white acrylic paint with perhaps a touch of lemon yellow) is confined to adding just a small amount to soften the edges of those areas where I have applied masking fluid. It helps enhance the sense of light and the glowing effect, I think. But that's as far as I take it.

Some artists dislike the constraints of having to consider and reserve the whites and highlights right at the beginning of a painting and so they use body colour as a means of adding the most intense light passages at a much later stage. This creates

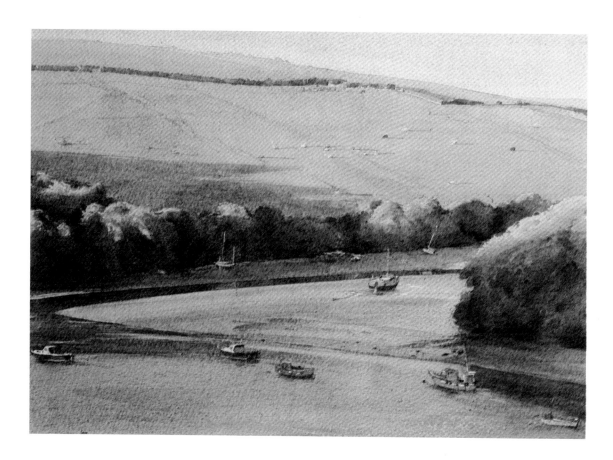

Bend in the River Fowey, Cornwall
28.5 x 39cm (11¼ x 15⅓in)

This was an instance when I came across an exciting subject but, without any materials with me, I could not work on a painting straight away. However, I was so impressed with the scene that I decided to return at the same time the next evening with my painting gear.

opaque, dense areas of light rather than translucent light and in my view seldom looks entirely successful or compatible in relation to the rest of the painting. In fact, watercolour is extremely versatile in its own right and I have never felt it necessary to introduce other media to create the effects that I wanted.

A watercolour can be a simple line and wash painting or, contrastingly, can be developed with a variety of methods into an immensely detailed result. My range of techniques is discussed and illustrated later in this section, on pages 24 to 41. *Morning, Sun Rising, Staithes* (left) and *Light on the River, Henley* (page 16) are good examples of the qualities that I like to develop in my paintings.

Note how the medium perfectly suits the depiction of particular qualities of light and how a restrained palette (choice of colours) often works best. The approach that I use for a certain painting depends on the subject matter and the circumstances. For example, outside, with a *contre-jour* subject and consequently a limited amount of time, I normally paint 'fast and loose'. On other occasions I choose what I call 'the middle way', in which I can work on areas separately but then maybe unify the painting with an overall wash. Or, alternatively, for a complex subject when long-term concentration is possible, I adopt a much more considered approach. For every painting I usually start with a big, wet-into-wet general wash to create a ghost effect for the overall image. These methods are discussed in detail in *Working Methods*, on pages 131 to 143.

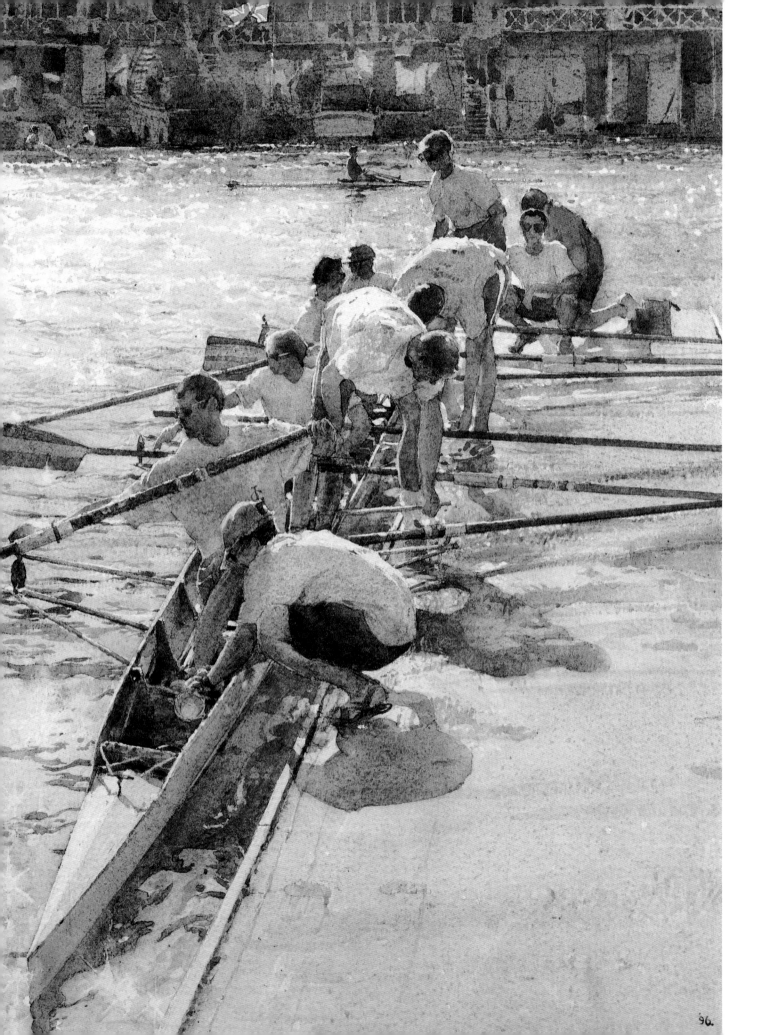

96.

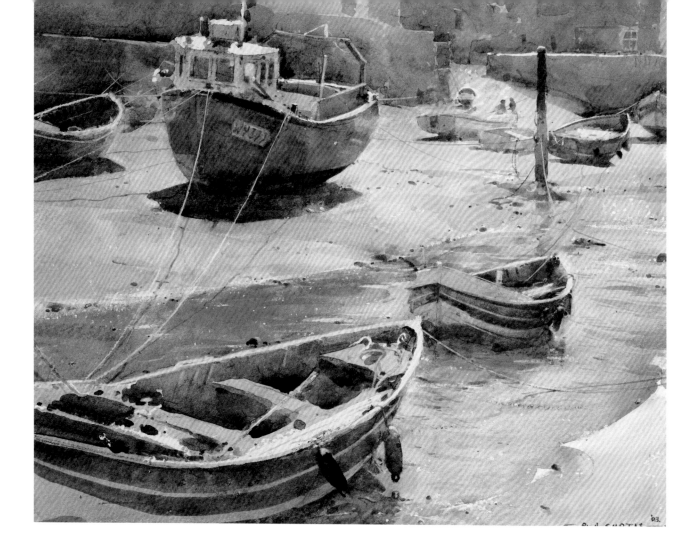

above *Cobles on the Beck*
39 x 57cm (15¼ x 22½in)

With the tide and light gradually changing, this type of subject demands a fast-and-loose approach using bold washes combined with sound drawing.

left *Light on the River, Henley*
39 x 28.5cm (15¼ x 11¼in)

Careful observation, sketches and photographs are the essential forms of reference for the paintings of Henley Regatta, held on the Thames, that I regularly exhibit each year.

right *Pantile Rooftops, West Cliff, Whitby, Yorkshire*
39 x 48cm (15¼ x 19in)

While I normally work on a standard-size sheet of paper stretched on a board, there are occasions when the subject demands a slightly different shape, as here.

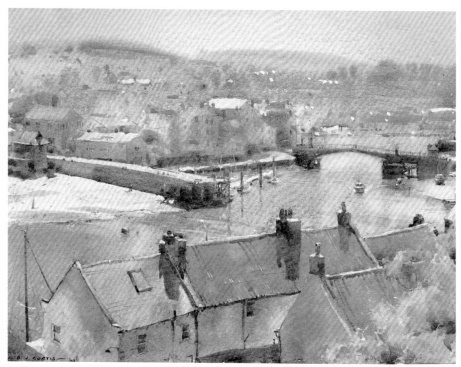

History and Context

Another attraction of watercolour is its sense of history; the fact that there are numerous fine artists and watercolour paintings that we can study and be excited and inspired by. Particularly in Britain, there is a long tradition of watercolour painting and artists continue to respect and build on this. My own motivation and inspiration has come from the great painters of the late 19th and early 20th centuries, notably those of the Staithes Group and the Newlyn School.

There can be immense value in looking at paintings by other artists and I suppose there are very few watercolourists who have not been influenced by something they have admired in another painter's work. However, I do think it is important to be true to yourself – to try to develop your own way of expressing ideas. It is fine to pluck the odd idea from here and there but, if you rely on more than this, you run the risk of simply becoming a clone of someone else. My advice is to concentrate on those aspects that you believe are individual about your work. Try to improve and develop those. The other point to bear in mind is that it does take quite a while to evolve an individual style, perhaps as long as ten years. It is a very gradual process.

The golden age for watercolour was in the mid-19th century when, in a period dominated by a fervent interest in landscape and nature, artists realized that the qualities of the medium were eminently suitable for capturing atmosphere, ephemeral effects and the picturesque. However, the origins of the medium date from many centuries earlier, arguably back to the ancient civilizations of China and Egypt. The Egyptians painted on papyrus rolls with a transparent coloured medium that was similar to present-day watercolour. It was actually made from earth and mineral pigments blended with gum arabic and egg-white. Later, a type of watercolour was used for illuminating manuscripts and painting miniatures.

From Renaissance times to the late 18th century watercolour gradually evolved into a widely accepted painting technique, although at first its use was mainly confined to the preliminary roughs and studies made as reference for large oil paintings. There were some artists, however, who saw the potential in using watercolour for its own sake, among them the German painter and engraver Albrecht Dürer, who was one of the first great masters of the medium. In the 17th century artists began experimenting with a loose wash technique, albeit with a very limited range of colours, sometimes working directly from the landscape. When the Grand Tour became fashionable, and with the additional demand for pictures of country houses and estates, watercolour was widely used to tint topographical prints and drawings.

Watercolour painting began to flourish in the late 18th century and early 19th century when artists such as Sandby, Towne, Cozens, Girtin, Cox, de Wint, Constable, Turner and Cotman introduced a wide range of techniques, both for the studious and the spontaneous approach. It also attracted a great deal of interest from amateur artists – so much so, in fact, that it became known as the 'English national art'.

The success of watercolour painting in England spread to Europe and other parts of the world. Watercolour is now a popular medium for the travelling artist and its potential is continually being explored, often with immense skill and inventiveness. It is a liberating medium. From the traditional approach, to wet-

into-wet abstracts or photo-realist portraits, artists have shown that it suits all manner of styles and techniques.

Freedom and Expression

Like any form of creative expression, watercolour painting is a means of communicating ideas and feelings in a personal way. A crucial factor in developing a personal style is a willingness to explore the medium and find out how it responds and what it will do for you. When I first started painting in watercolour I did a lot of experimentation and I was lucky enough to paint with some very respected, competent artists. I also worked in pastel and chalks for a while and in fact there was one year when I concentrated almost exclusively on drawing, which is still, I believe, a vital skill for all artists.

Drawing helps you isolate those elements in the subject matter that are important, and equally it provides a sound structure from which to develop the painting. So often one comes across paintings in exhibitions that are full of great ideas and interesting treatment, but terribly drawn. A good introduction to watercolour painting, I think, is to work with a line and wash technique, with the emphasis on the drawing. After a time, when you feel confident about the drawing, you can gradually place more importance on the colour washes, using these to create the sort of transition in form and effect that you require.

With experience you discover that watercolour allows you immense freedom and scope for individual expression. You find, for instance, that you can create a transition from crisp drawing to subtle tonal values all within the one wash. Dry-brush work, wet-into-wet, lifting out, variations of warm and cool or dark and light colour, lost and found edges, and so on – there are many different watercolour effects that are possible for all kinds of subject matter, from expressive skies to delicate flower studies.

Materials and Equipment

Because watercolour is such a compact and lightweight medium, there is no difficulty in carrying everything you need for a painting trip. All of my painting equipment fits into a small rucksack and additionally, when I go out to paint, I take a folding stool and a sketching easel with me. For me, one of the most important items of equipment is the palette. I like a really good-quality palette, one with a surface that is not so shiny and enamelled that all you get is separate globules of paint rather than a well-mixed, usable wash. I have a beautifully balanced Binning Munro palette, now perhaps over one hundred years old, which was left to me by another artist, and I also own the modern-day equivalent – a David Craig palette. I like a selection of brushes, but I never use flat brushes. The strokes from these can look very mechanical, I think. For painting large areas with an overall wash I prefer to use a No.12 round sable or a polisher's mop. My paints are mostly tubes of Winsor & Newton Artists' Water Colours and Old Holland Watercolours, plus a tube of white acrylic paint. Good-quality paper is also important. I generally use watercolour blocks or a Whatman pad when I am painting outside on a small scale. Otherwise I might

Boats pencil sketches

Small, observed studies in a sketchbook such as these provide very useful reference material to incorporate into a studio painting later on. A drawn image has far more impact and integrity than a photograph.

choose Arches 600gsm/300lb paper stretched on a board. I like a rough surface paper with some tooth, but not too much.

The rest of my painting gear is kept to a few essentials: I use some kitchen roll for soaking up excess paint; tinted masking fluid for preserving the light areas of the painting; and a 2B, 3B, 4B and 6B pencil, or sometimes a graphite stick, for the initial drawing stage.

Paper

I recommend a fairly heavy quality paper and one that has a surface with an irregular grain. The heavier papers (600gsm/300lb) will take far more punishment and allow you greater freedom for techniques such as dry-brush and lifting out. Another advantage of a heavyweight paper is that it is less likely to cockle when framed under glass. However, it is a good idea to experiment with a number of papers until you find one or two that suit your particular working methods.

Beckside Moorings
28.5 x 39cm (11¼ x 15¼in)

For this two-stage location painting I deliberately chose to work on paper from a Saunders block, selecting it because of its excellent lift-out qualities.

Busy Market Day, Alcudia, Mallorca
39 x 57cm (15¼ x 22½in)

This is an example of a studio painting made on Arches paper. Arches will withstand plenty of wetting, lifting out and other techniques. It offers me everything I require of a paper.

Tinted papers, such as Two Rivers de Nimes (available in green, cream, sand, oatmeal and grey), are ideal for those subjects in which there is a distinct underlying tonal or atmospheric quality. The particular tint will give a certain mood and unity to the painting. If I am not working on a watercolour block or in a pad, then I use paper that is stretched on a sheet of smooth plyboard. I try to always have a stock of 10 or 12 stretched sheets of paper available, with a choice of different types and sizes.

I like the paper to be drum-tight on the board, to create the sort of bounce that you find with a well-stretched canvas. I have tried various ways of stretching paper, but my current thinking, certainly with Arches 600gsm/300lb Rough, is to place the sheet in a shallow bath of tepid water for only two or three minutes. Then I lift it out straight onto a board, sponge round the edges of the paper to soak up some of the water, and finally secure each side with a length of 5cm (2in) water-based gumstrip. I never use masking tape. I keep the board in a horizontal position and leave the paper to dry at room temperature.

The advantage of this method is that the paper retains most of the size (all papers contain size, otherwise they would be totally absorbent), yet it still responds well to lifting out and all the other effects that I like. For really atmospheric subjects, where you want a soft-focus, diffused quality, it is a good idea to soak the paper for longer.

Paints

My advice is to choose artists' quality paints. It is true that they are more expensive than student quality watercolours, but because they contain a greater proportion of pure pigment and less binder the colours are far more intense and they go further. So not only do they give better results, they are actually more economical in the long run.

I prefer tube colours to pan colours. Paint from a tube is much easier to mix, especially if, like me, you want big, sloshy washes of colour. I buy large tubes and fill the various paint wells in my palette from these.

Like so many aspects of painting, deciding on the best palette (range of colours) to use is something that is gradually determined through experience and experimentation. I made some massive mistakes with the choice of colours that I used during the early part of my career, choosing colours such as Prussian blue, Payne's grey and Hooker's green. But I learnt from those mistakes and I now have a palette that is quiet, with a non-insistent group of colours, yet ones that will give me all the different lights and darks, warms and cools, and other variations that I might need.

Essentially, my palette consists of some primaries, some gentle blues, and some earth colours. I set out these colours on the palette as follows: (starting from the point furthest from the body) cobalt green, which is beautifully gentle – like a viridian but with a lot of body colour in it; viridian, which is another cool green and also very controllable; French ultramarine, good for making a strong dark when mixed with burnt sienna; cerulean; cobalt; cobalt violet; raw sienna; permanent rose, which is my equivalent of alizarin crimson; cadmium orange; burnt sienna; gamboge; Indian yellow; and cadmium red or vermilion. I use this palette for both location and studio work. It suits all subjects, although sometimes I also add small amounts of other colours, such as yellow ochre and light red.

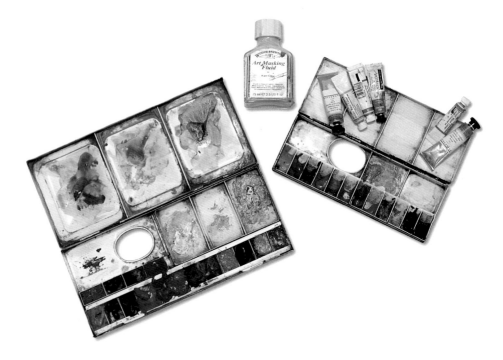

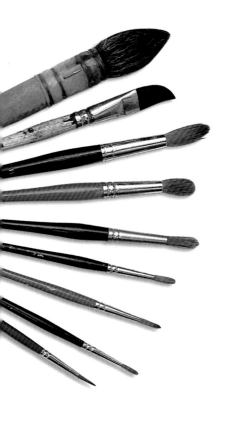

Brushes

I generally use sable brushes. These brushes can hold a large quantity of paint, but will release as much or as little as you wish. They are made with hair that is fine yet resilient and capable of tapering to a sharp point. As well, they have a spring and flexibility which allows both spontaneity and control. The paint-holding capacity is very important, because when you apply a wash you want to be able to work across the whole area in one sweep. Stopping to reload a brush can allow the paint to dry and so create hard edges or 'tide marks' within the overall area of colour.

I have a selection of round sables in sizes 2, 3, 4, 5, 7, 12 and 14 and I also use quite a few little riggers, some new and some worn. I find that a rigger that has the point worn down is actually more controllable and will give a good range of effects.

For applying masking fluid I generally use a cheap squirrel-hair brush. Masking fluid is extremely difficult to remove from brushes and invariably any brush chosen for this purpose will be ruined after a while and have to be thrown away. Therefore you should never use a good-quality brush, because the masking fluid will clog the hairs and spoil the potential for sensitive and flowing strokes. There are many suggested methods for cleaning brushes after working with masking fluid. Some artists recommend synthetic brushes, which can be rinsed in lighter fuel. I clean my squirrel-hair brushes in water, but I never use the same water for painting, as even diluted masking fluid can damage brush hairs.

Other equipment

My painting equipment is deliberately simple and low-tech. For example, I use a large soft-drink bottle for carrying a supply of water, while my water container for painting is a small tub suspended on a length of string beneath my easel.

Similarly, the easel is not the latest super-lightweight aluminium design, but rather a sturdy and reliable wooden sketching easel that I have had for 35 years – in fact a Winsor & Newton Perfect Easel. But it does allow me to work with the board at an angle of about 30° to 40°, which I think is essential for most watercolour techniques. In my view, you cannot work successfully with the board on your knee or with it held completely vertically.

In the studio the most important consideration is lighting. I have lots of lights so that I can create just the sort of lighting conditions that I want for a painting. There are 10 lights in all, including daylight-simulation fluorescent tubes and spotlights, and angle-poise lamps. This gives me the scope for close, controlled work as well as a much freer response. For instance, for a high-key painting I will have most of the lights on, and I can rely on the lighting being consistent throughout the duration of the painting.

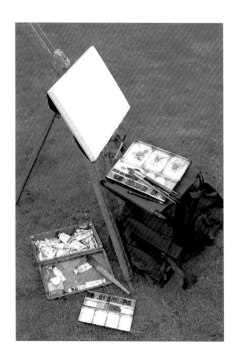

Exploring Techniques

As far as techniques are concerned the first essential is to master the mixing and application of the colour wash – starting with a flat wash (even colour) and then moving on to a graduated wash (one in which the colour gradually changes from dark to light). Take a sheet of paper, mix some colour, and with a large brush, practise making long horizontal strokes from one side of the paper to the other. Working quickly, you should be able to build up an area of colour in this way.

They try the same process but making each stroke slightly weaker than the last (by adding a little more water), and so creating a graduated wash.

It is by exploring watercolour in this way that you begin to appreciate its unique characteristics and discover the potential for different nuances of colour and other effects. Gradually you should be able to work with superimposed washes as well as combine loose, wet-into-wet areas within a wash with more structured and defined shapes. Skills and techniques are aspects of watercolour painting that slowly evolve. Success in these areas is largely determined by your enthusiasm and commitment to experience – so practise and persevere!

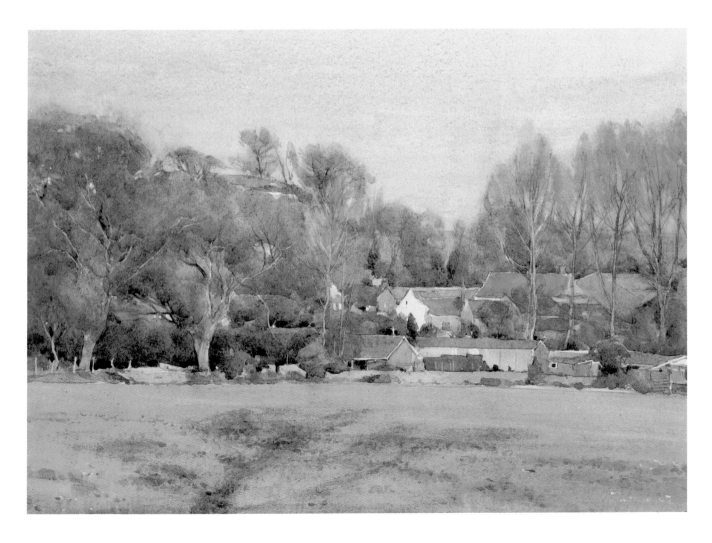

Something that is immediately apparent about watercolour is its ephemeral quality. Also, we quickly learn that the most successful paintings rely on creating an impression of the subject – giving a hint rather than a detailed statement.

Wash techniques

Whatever type of wash is used, its character is much influenced by the choice of paper and whether the surface is dry or damp. I would choose a dry paper for a graduated wash because, particularly with the board at an angle, the paint is not so quickly absorbed and therefore the wash tends to run downwards, making it easier to weaken it as it does so. On the other hand, for a general soft, diffused wash, which is the sort of wash I often use at the beginning of a painting, it is best to wet the paper first.

For this approach I usually start by flooding the whole paper with water and then I leave it for a couple of minutes. The timing has to be just right: if the washes are applied too soon, the colour runs down the paper; if too late, then it creates a broken, patchy effect.

A simple graduated wash is particularly good for a sky statement and also great for painting water. While the paint is still wet you can drop in other colours to create diffused reflections and shadows. In *Clock Tower, Doncaster, Yorkshire* (page 26) I have used this technique extensively. There are different types of wash effects across the sky, the buildings and the shadowy foreground. Notice too the lit edge on the left of the building, which was initially picked out in masking fluid. This allowed me to freely run the sky wash right across this area, yet reinstate the crisp outline of the buildings later, when the masking fluid was removed.

Another feature of the sky in this painting is the way that the paint has granulated. Some pigments have a tendency to separate from water when used in a wash, giving an interesting grained or textured effect which is known as granulation. It is a lovely effect for certain subjects and something that I thought I would deliberately use here for the middle part of the sky. Cobalt with a little light red seems to work well, especially when painting skies, but there is always an element of chance. I believe other colours that have this characteristic include cerulean blue, burnt umber, raw umber and yellow ochre.

Approaching Tickhill, Yorkshire
28.5 x 39cm (11¼ x 15½in)

In this painting the washes were applied to biscuit-coloured paper, which I chose in order to enhance the autumnal effect. In the few areas where I required a really light colour, such as the gable end of the house in the centre, I used a touch of titanium white acrylic colour.

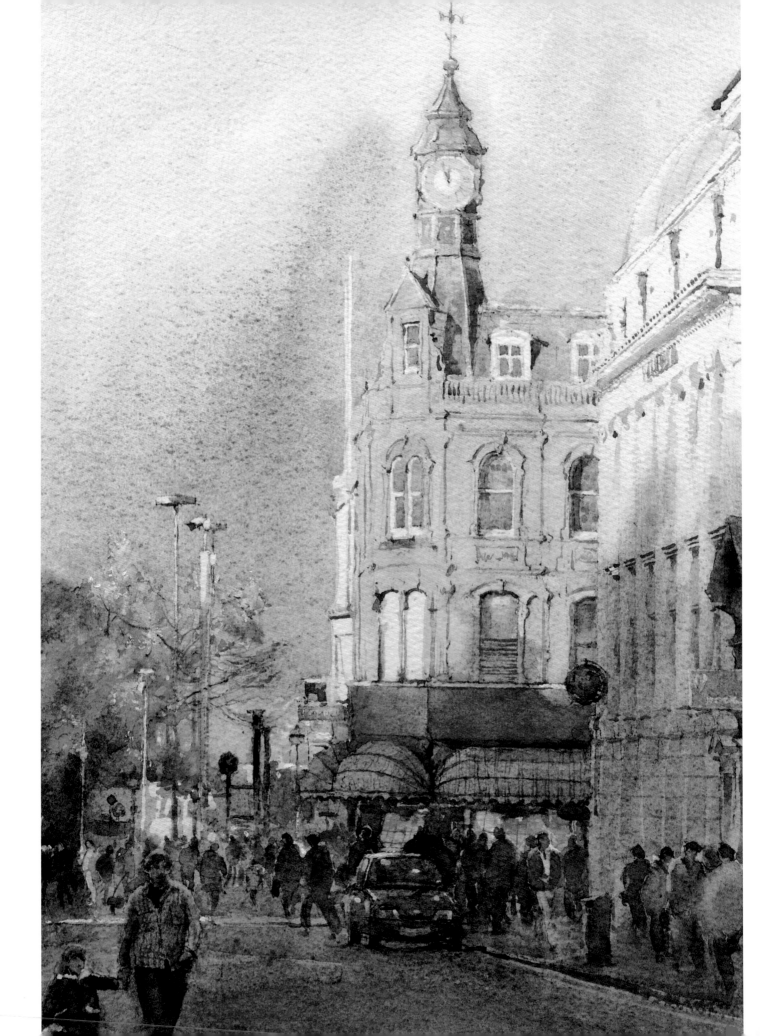

Clock Tower, Doncaster, Yorkshire
39 x 28.5cm (15¼ x 11¼in)

The entire background area in this painting
was made with a single graduated wash,
starting weakly and then increasing in strength
lower down. The lit edge on the left-hand side
of the building was initially protected with
masking fluid, so allowing me to apply the
wash freely and without fear of losing the
crisp outline.

Wet-into-wet

The wet-into-wet technique can be used at any stage in a painting to produce
spontaneous, subtly blended colours and effects, but for me its main use is for
what I would call a 'foundation treatment'. The majority of my paintings now
start with an overall wet-into-wet wash that I vary in tone and colour to give a
basic ghost-like indication of the subject. I often put a fair amount of weight
into this initial wash, in the knowledge that a lot of it is going to drain away. But
by having started quite boldly I know there is going to be enough pigment left
to count, particularly in terms of creating a tonal reference from the strongest
dark to the reserved lights.

Because the first wet-into-wet wash is soft-edged there is little chance of
overstating things. I believe that if you begin with understatement you can
subsequently reach a point of further development without undue danger of
overdoing everything. It is important to observe carefully all the changes within
your subject and adapt the wash accordingly. You have to be prepared to mix
and apply, mix and apply, using all the reservoirs in your palette and working
very quickly to indicate changes from warm to cool, dark to light and colour to
colour. It takes a massive amount of energy to do this, but the more information
you lay in with this first big wash, the better chances of success later on.

Have some washes ready-mixed and decide whether you are going to run one
wash against another on dry paper or whether the paper needs to be damp. This
depends on the subject matter and how best to interpret it. Mostly I work on
damp paper and I usually begin by mixing large amounts of three approximate
primary colours: raw sienna, cobalt blue and cobalt violet mixed with some

right **Matthew, Early Days**
28.5 x 39cm (11¼ x 15¼in)

Here, sound drawing was important to establish
the necessary shapes and proportions and then
I added a sequence of unifying, transparent
washes, some of which, as in the background,
were created totally from imagination.

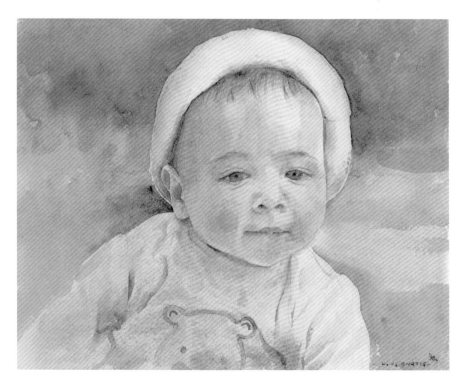

viridian. You have to be incredibly bold and generous with the paint, I think. I may use quite a few pounds' worth of paint on that first wash and while most of it might run down and end up on the ground, I know there will be enough pigment left to make that important first statement. See *The Fishing Party, Thorne Marina* (right).

Rising Tide, Staithes Beck
19 x 28.5cm (7⅜ x 11¼in)

There were some lovely shapes in this subject and because I was working on a small scale I could make fast progress.

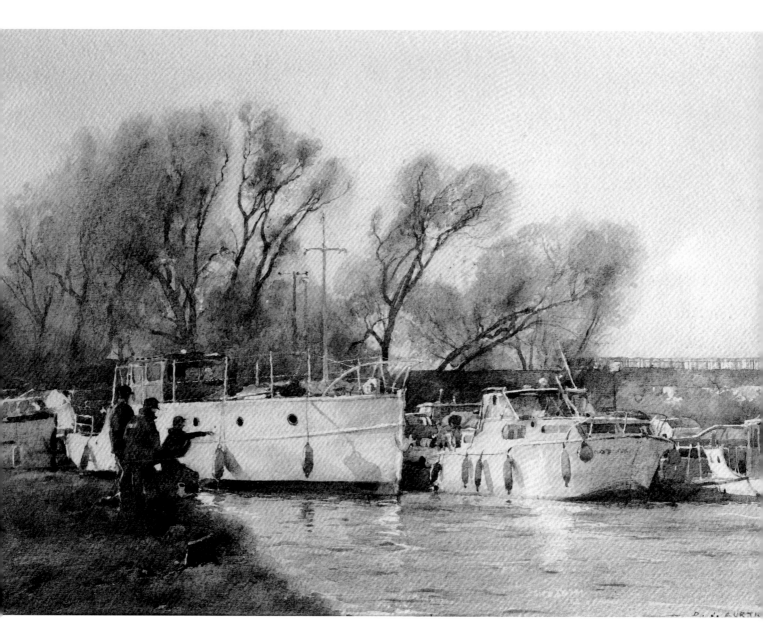

The Fishing Party, Thorne Marina
28.5 x 39cm (11¼ x 15¼in)

Wet-into-wet is an ideal technique for creating soft, diffused outlines,
like those of the trees in this painting. I quickly added the trees while the
sky wash was still wet, so the colours slightly fused together. But the
right timing is crucial!

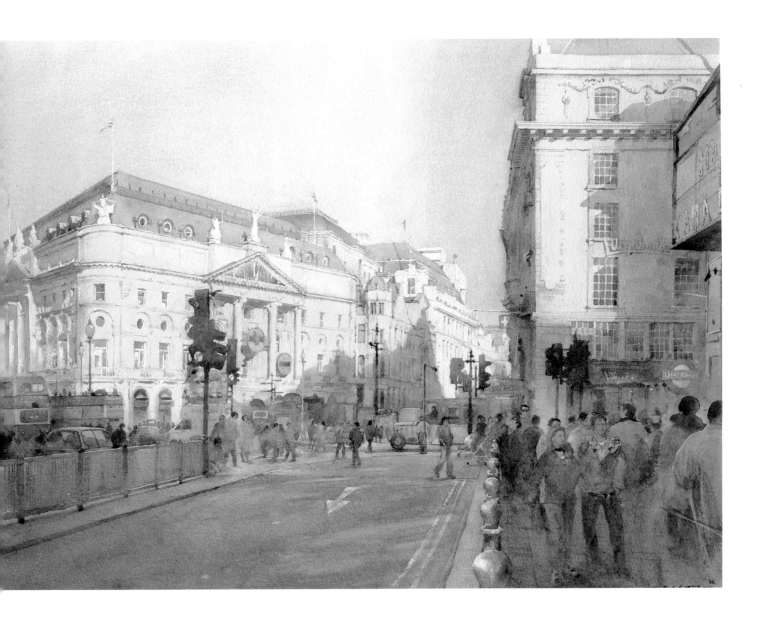

Piccadilly

57 x 77.5cm (22½ x 30½in)

The lost-and-found technique is perfect for capturing the impression of a crowd of people. I like to just pick out one or two facets of each figure – the highlight on a shoulder or face, for example. You rarely see the feet in any detail, and this adds to the sense of movement.

Lost-and-found edges

Most paintings are about the effects of light, for it is generally the particular strength, direction and type of light which together define shapes, model forms and create the overall mood and impact of a scene. Often such effects are quite subtle and are best conveyed by the interplay of tonal contrast and tonal similarity, a technique that is also known as 'lost-and-found'.

In practice, what we have to decide in a painting is whether to depict a shape as light against dark or dark against light. Where part of a figure or object has the same tone as the surrounding area the outline is said to be 'lost', because there is no obvious defining edge. In contrast, 'found' edges are those that show up clearly, where the object is lighter or darker than the background. Subjects that are seen *contre-jour* (against the light) or in conditions of bright sunlight with strong shadows are the most likely ones to involve lost-and-found effects. I particularly remember enjoying the play of darks and lights and the resultant contrasts of lost-and-found edges in my painting *Piccadilly* (left).

In the background of this painting there is the most wonderful shadow that is creeping across the building. It is a soft-edged shadow. The method that I used for painting it, I remember, was first to sketch in the general shape of the shadow and then to add water all the way round the edge. I applied a wash of cobalt blue and raw sienna up to the wet edge, allowing the colour to run into it slightly and so create a soft, diffused outline. This made an effective contrast between the shadow area and the bright, crisply defined part of the building above.

Many other passages within this painting include a similar play of tonal counterchange, the most dramatic being the intensely dark shapes of the traffic lights on the right against the sunlit building beyond. You can add darks either with a single bold wash or by building the strength of the dark with a succession of washes. At the other extreme, highlights can be made by masking out with masking fluid or by using body colour or the lifting-out technique (see page 37).

Pages 32–33 *From the Cowbar Side, Staithes, North Yorkshire*
39 x 57cm (15¼ x 22½in)

I used masking fluid to protect the whole of the river area in this painting so that I could start with generous wet-into-wet variegated washes across the entire composition.

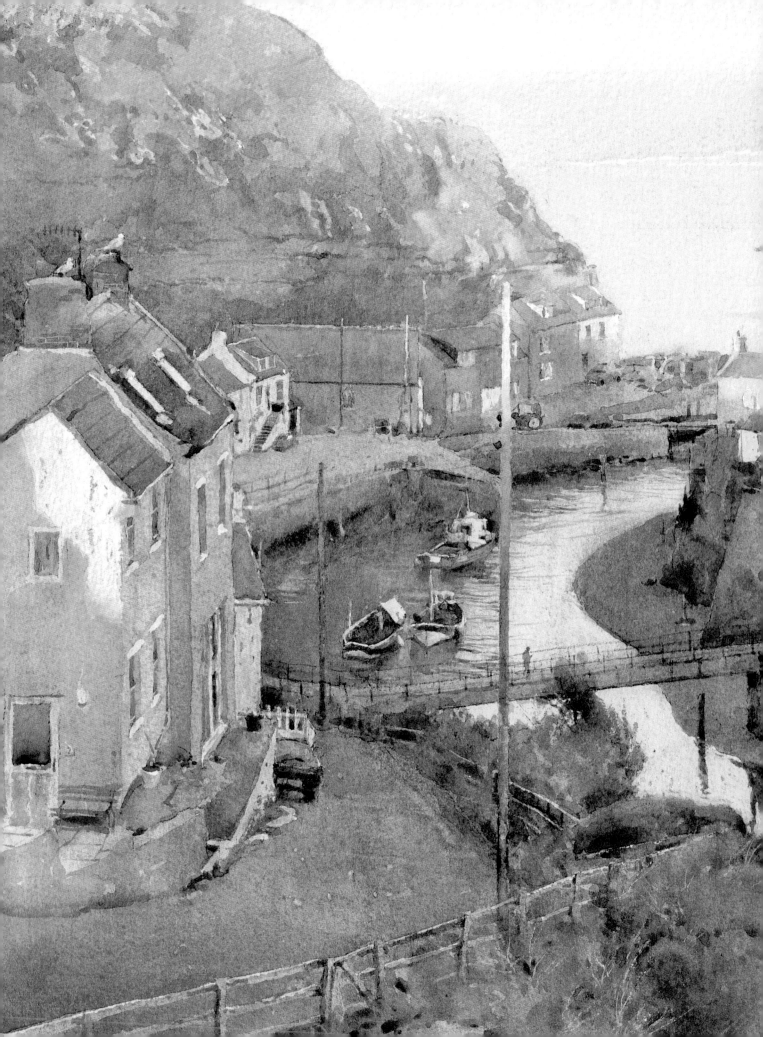

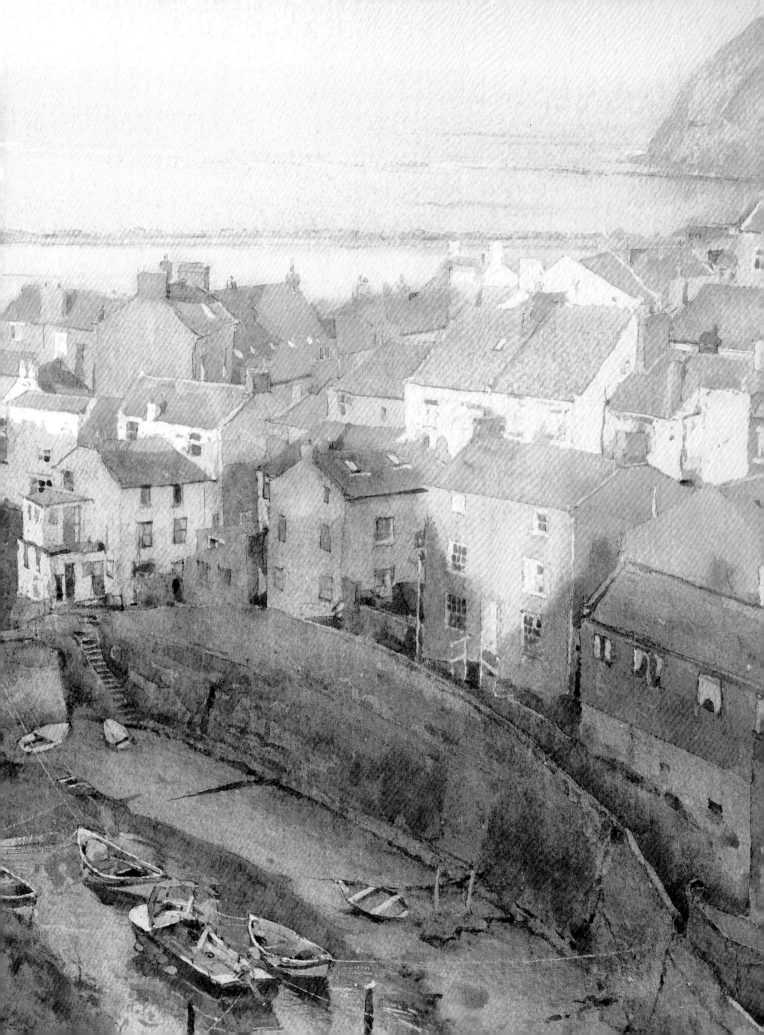

Blending

Very rarely do you find an area within a painting that has a consistently even colour right across its surface. Usually, if you look closely at the subject, you will discover that what at first appeared to be a uniform area of colour does in fact contain many subtle variations. Consequently, instead of using a flat wash you will require one that incorporates slight changes in tone. But such changes must always be sensitively and imperceptibly blended, so that while the initial impression is of a whole shape, a second glance reveals that this is a shape with variety and interest.

Blending usually works best on damp paper, slightly overlapping one wet colour against another. Normally I do not use this technique until I am about two-thirds of the way through a painting, when I am developing areas in a more considered way over the initial type of wet-into-wet wash that I discussed on pages 27–29. At this stage in the painting I like to sharpen up and accentuate various aspects and in particular I search out shadow areas that have that chop-and-change characteristic, as in *Keeping Watch, Stainforth Basin* (below).

Keeping Watch, Stainforth Basin, Yorkshire
39 x 57cm (15¼ x 22½in)

The shadows were the most important aspect here. I placed them early, blending them into the surrounding areas.

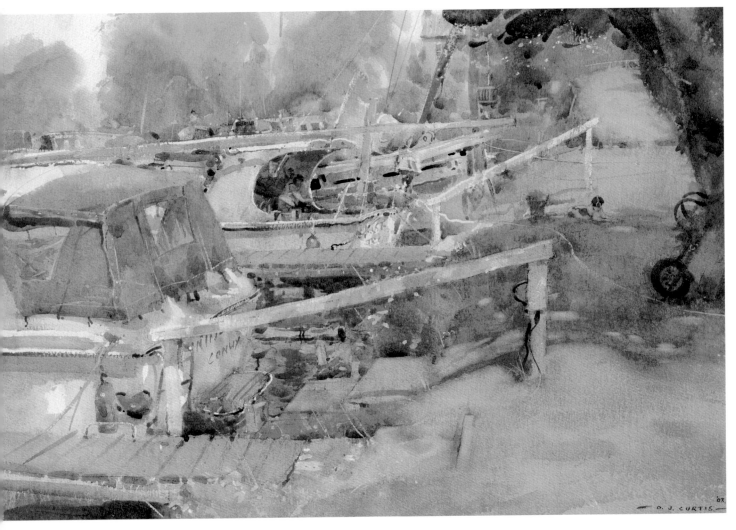

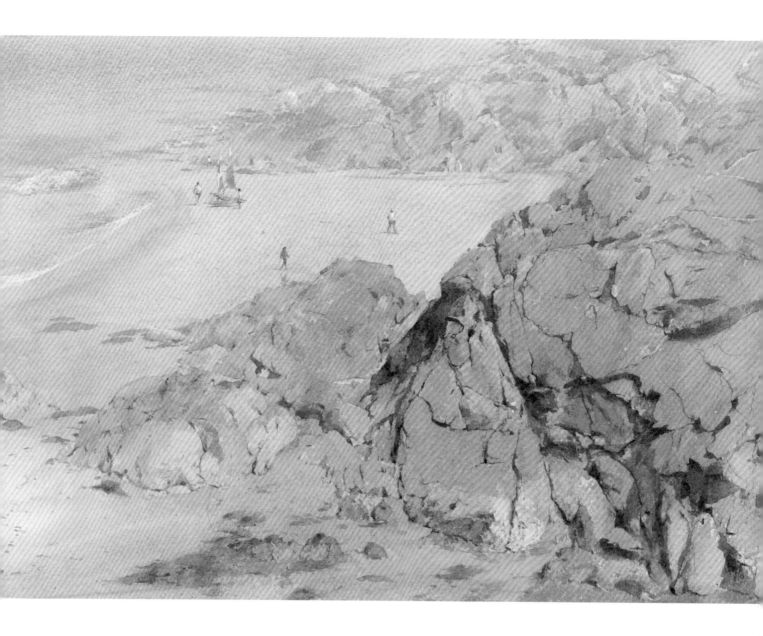

Tudweiloig Beach, Lleyn Peninsula, Wales
39 x 57cm (15¼ x 22½in)

I painted this watercolour in the studio from a careful oil study that I made on site. In the watercolour I especially enjoyed capturing the structure of the rocks, which naturally, being a rock-climber, is something that greatly interests me.

Again, for this technique it is very important to have the washes ready mixed. Start with a quantity of wash that suits your assessment of the overall sense of colour and then mix lighter and darker, warmer and cooler modulations of the parent wash. Control the amount of wash so that it is not too wet and gradually work across the area, adding the variations of colour wet against wet. I have used this technique for the texture, crevices and shadows in the foreground rocks in _Tudweiloig Beach, Lleyn Peninsula_ (above).

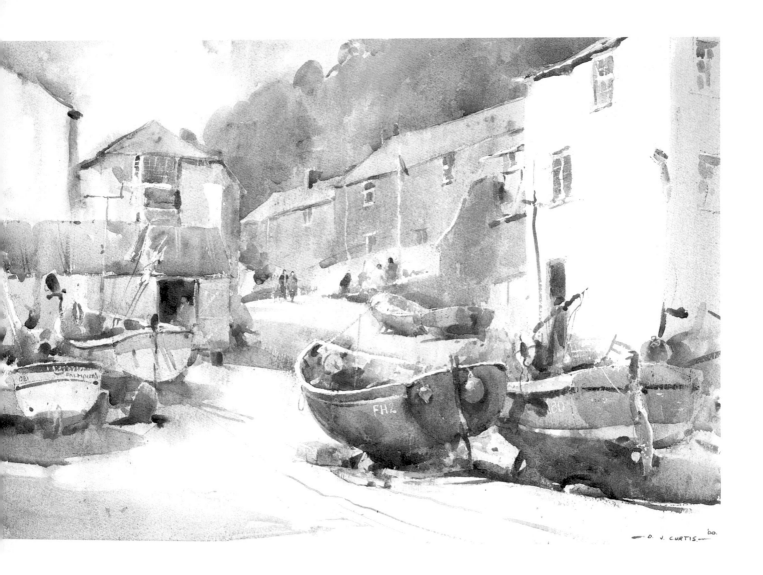

Line and wash

I used this techniques a lot in the past; perhaps it appealed to the designer in me. It is a lovely way of working, but it does require good drawing skills. The emphasis is on a sound drawing made in pen and ink, fibre pen or with a brush, which is then developed with some gentle washes to suggest something of the tonal and colour qualities within the subject. Line and wash is a particularly good technique for location studies made in a sketchbook.

Occasionally I still use this method for larger, resolved paintings, as in *Portloe Harbour* (above). For such paintings I make the initial drawing with a No. 2 or No. 3 rigger brush and some fairly neutral paint, perhaps a mix of French ultramarine and burnt umber or French ultramarine and raw sienna. The rigger brush allows greater freedom in the strength and character of the line, with the added advantage that, because they are made with watercolour, such lines readily harmonize with the subsequent washes of colour. With pen and ink, the lines are more insistent.

Portloe Harbour, Cornwall

39 x 57cm (15¼ x 22½in)

There were a lot of extensive, well-lit areas in this subject which, after the initial washes, relied principally on sound drawing.

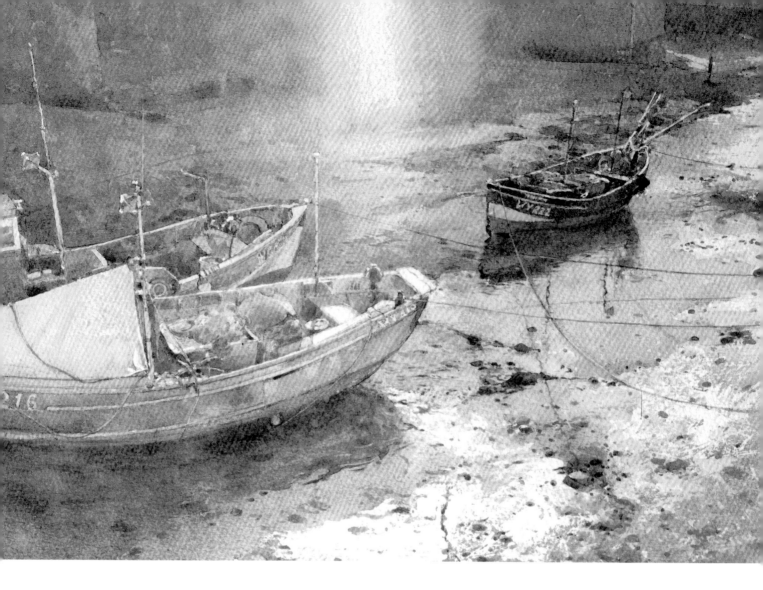

Lifting out

The success of any technique relies to a large extent on the type of paper being used, and this is particularly so with lifting out. You need a tough paper such as Whatman, Saunders Waterford or Arches. Some of the tinted and rag papers also respond well. You can use this technique to soften or reduce the intensity of small areas of colour or to create soft accents of light – perhaps where you have forgotten to apply masking fluid. However, much depends on the colour that you are lifting out. Some colours have a far greater staining power than others. In any case, it is seldom possible to remove every trace of colour; usually some colour is absorbed into the fibres of the paper.

To lift out a patch of colour, first wet the area with some clean water and then tease out the colour with a brush. I use a rigger on its side. I prefer the rigger because it is very flexible. Once most of the colour has been removed, lightly dab the area with some tissue paper to soak up any remaining wet colour.

A big advantage with lifting out is that it is very controllable; you can take your time. In *Winter Moorings, Staithes Beck* (above), you can see that I have used the lifting-out technique to suggest the interesting blast of light that appeared between the two buildings in the upper part of the subject.

Winter Moorings, Staithes Beck
28.5 x 39cm (11¼ x 15¼in)

Here, to suggest the magical shaft of light that came from between the buildings and caught the stern of the boat, I decided to use a lifting-out technique. I wetted the central area with some clean water and then removed most of the previously applied wash with a brush and a sponge.

Dry-brush

With dry-brush, as the name suggests, you use just a small amount of paint on the brush, working on dry, rough-surface paper and dragging the brush across it to create broken areas of colour or interesting textural brushstrokes. The technique can be used to suggest various light and detail effects, as in The Royal Exchange Building (below). I also think that it is particularly good for painting long shadows and for adding darks in line-and-wash sketches.

Use dryish paint for this technique. You can remove excess moisture from the brush by lightly skimming it across some tissue paper. For the best results the brush should be held in a fairly horizontal position. Hold it between your thumb and second finger, parallel to the paper surface, and quickly drag it across the chosen area, relaxing the stroke as you do so.

The Royal Exchange Building, London
28.5 x 39cm (11¼ x 15¼in)

Some of the details in this architectural subject were made with dry-brush work, as were the deep shadows under the architrave at the top of the columns. In fact, there is an interesting story about this subject. I spotted it while waiting at the traffic lights in my car. Instantly I shouted to Trevor Chamberlain, who was with me, to grab my camera and he managed to take a photograph before the lights changed to green. It is by far the best view of The Royal Exchange, but you couldn't possibly paint it from the middle of the road!

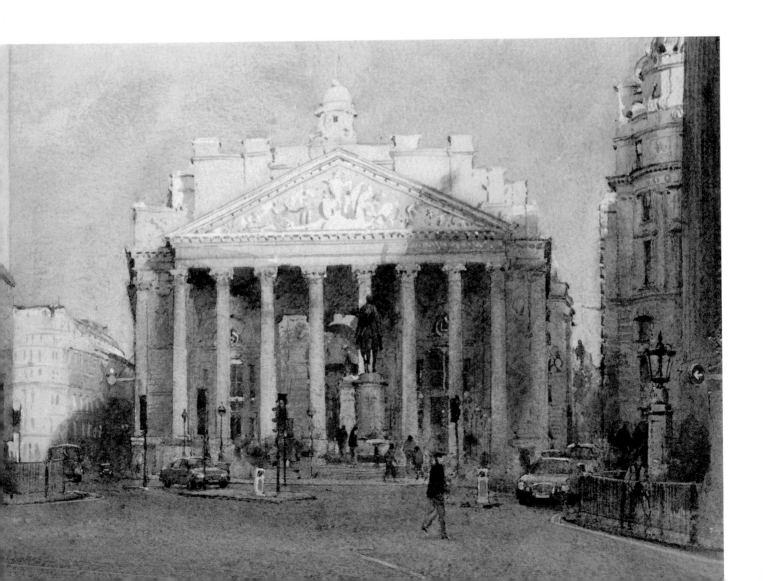

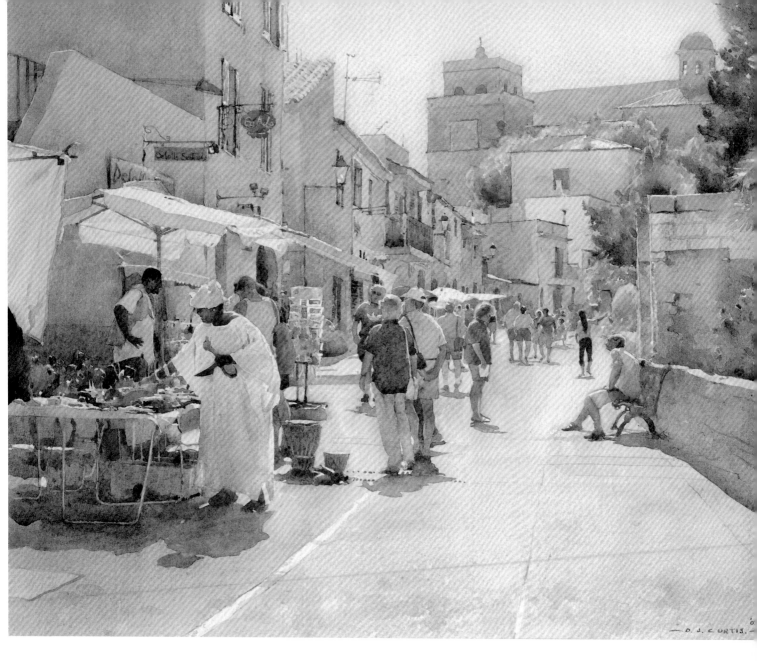

The Tuesday Market, Alcudia, Mallorca

39 x 57cm (15¼ x 22½in)

This very considered painting, produced in the studio from memory, drawings and photographs, involved quite an extensive use of masking fluid to reserve the whites and highlights.

Masking out

I regard masking out as an essential technique to preserve the most important highlights. These key areas are established at the drawing stage and are protected with a thin application of masking fluid. Tinted masking fluid shows up much better than the off-white type. Apply it with a cheap fine brush. Do not be tempted to over-do the technique or fuss too much over the way it is applied. If it isn't right at the first attempt, rub it off when dry and start again.

Many of my subjects are *contre-jour* and for that reason masking fluid is integral to practically everything I do. A good example is *The Tuesday Market, Alcudia* (above), which I painted in the studio from sketches and photographs made on location. I used masking fluid for the figure in the foreground, the canopies, the white line on the road, the highlights on the distant buildings, and in various other places. It is a wonderful technique because, with the highlights protected, it allows you the freedom and confidence to use very bold washes. Ensure that the wash is completely dry before removing the masking fluid.

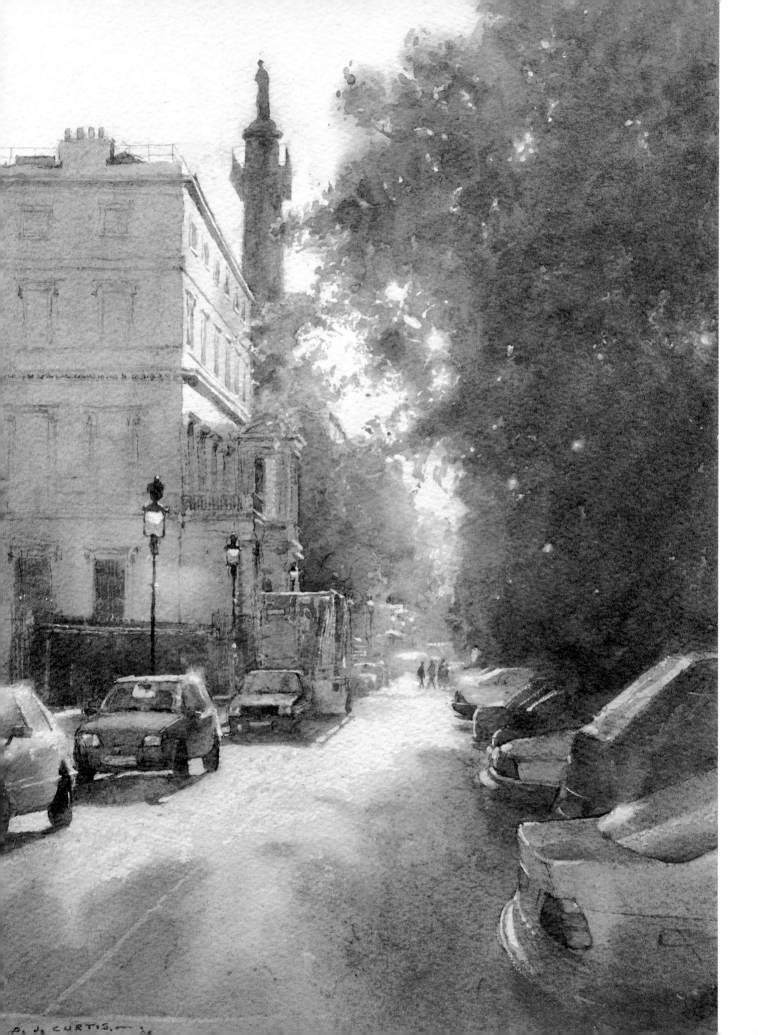

Highlights that have been masked out in this way can look quite stark, so I usually brush some water around the edge of the shape and tease some of the surrounding colour into it. Or, if I want to make the highlight really glow, I wet the surrounding edge again and add a touch of orange or yellow.

Body colour

As discussed on page 14, the extent and the way that you use body colour is entirely a matter for your personal judgement. It will depend on the type of painting and the sort of effects that you want to produce. For my own part, I love the transparency of watercolour and therefore I only resort to body colour in certain circumstances, and even then in a very limited way.

I occasionally use body colour for restating or emphasizing light effects, as a drawing vehicle for rigging lines and similar details, or for repairing or perfecting lines and shapes that were previously blocked out with masking fluid. I use titanium white acrylic paint, adding a touch of cobalt blue if I want a cool light effect or, contrastingly, a small amount of yellow, orange or red, if I want a warm, glowing light. See *Qualifying Day, Henley*, on pages 42–43.

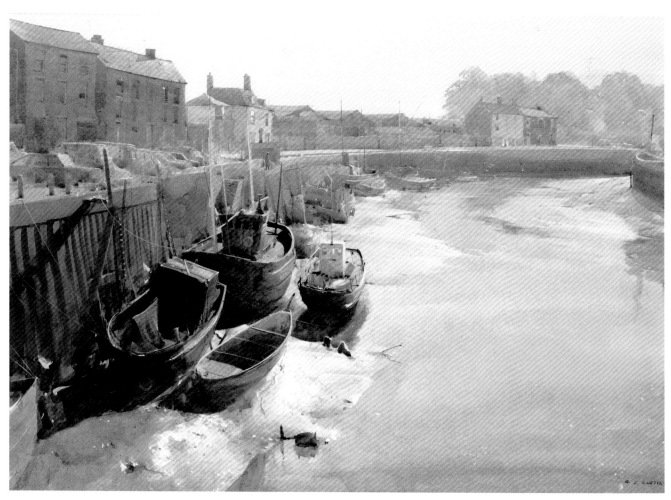

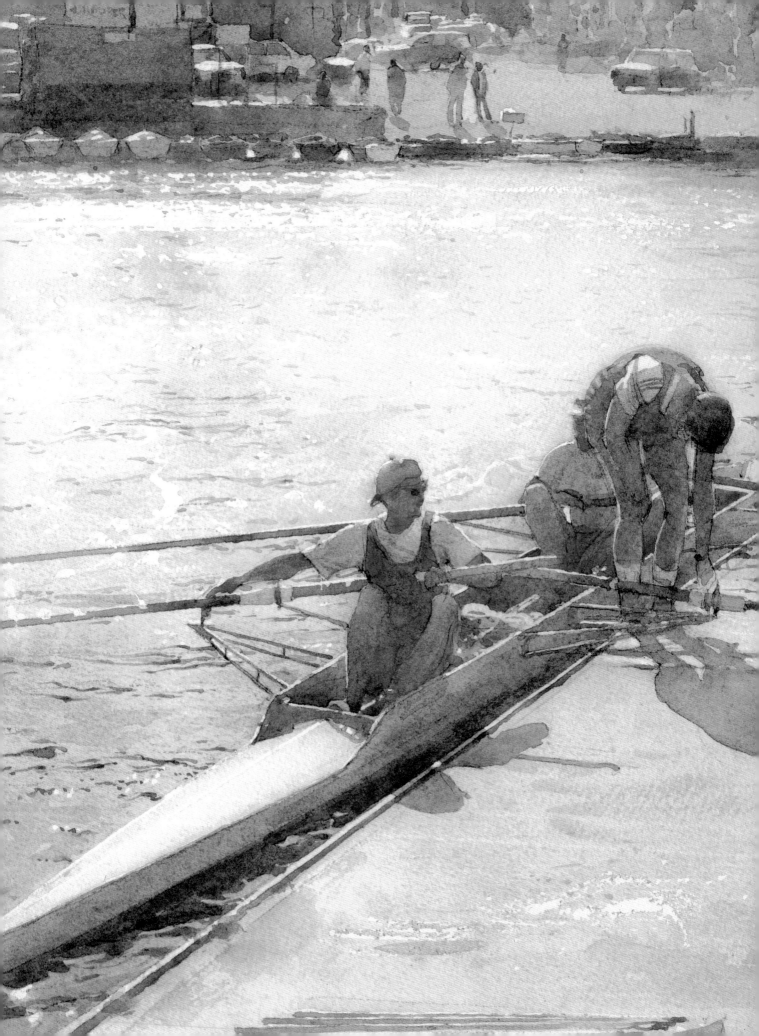

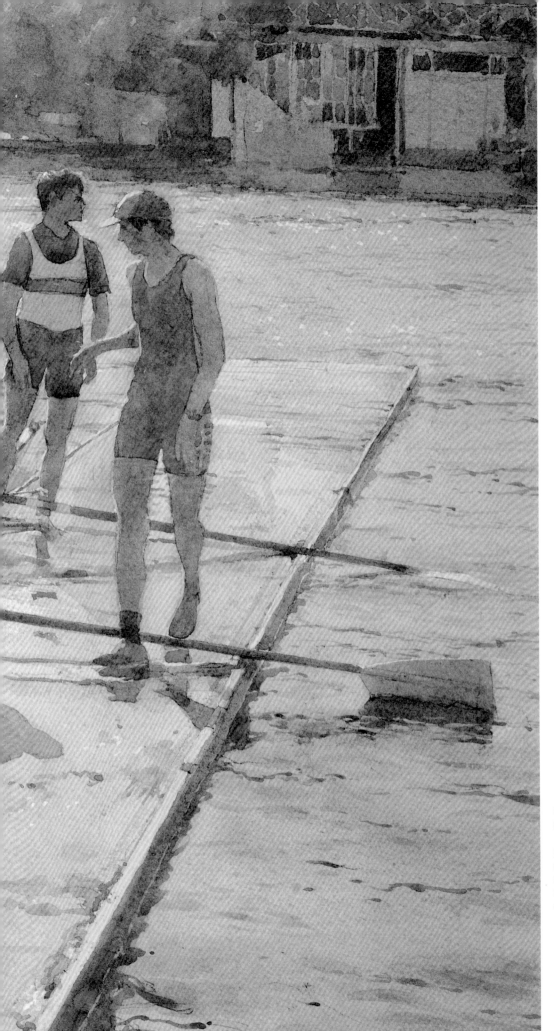

Qualifying Day, Henley
28.5 x 39cm (11¼ x 15¼in)

Here, to intensify the 'glow' effect
on the water in the background, I
added just a little titanium white,
lemon yellow and cadmium
orange acrylic paint.

2 Developing Ideas

A knowledge of materials, and some experience of using a variety of techniques, is essential for successful painting with watercolours. However, it also relies on acquiring skills in recognizing interesting, original ideas and being able to develop them to their full potential. Whatever the subject matter, composition is always an important consideration, as is the way that specific objects and shapes are drawn, and the subsequent use of colour. These aspects of watercolour painting are the subject of this chapter.

Drawing and Design

Drawing is a vital skill for all artists. Through drawing you learn to be observant and selective, which in turn enables you to focus on those qualities in a subject that make it individual and interesting. Drawing is also the most effective way to record reference material for subjects and ideas that you would like to paint later in a more considered manner in the studio, while the ability to draw shapes competently is always a key contributing factor to the success of any figurative painting.

As I have already mentioned, I strongly believe in the importance of drawing to provide a good foundation structure and sense of design for a painting. Quite often when I am visiting exhibitions I notice paintings that are technically very sound in their use of colour and handling of paint, but in which all this good work is unfortunately undermined by weak, ineffective drawing. It is a fact that, no matter how enthused you are about something you have seen, if you lack the necessary drawing skills you will not be able to convey the substance and character of the subject with the impact and success you had hoped for.

Occasionally you may have come across subjects that you were tempted to paint straight away because they seemed so appealing. But then, having worked on them for a while, you discovered that in fact their potential was quite limited. One way to avoid this sort of disappointment, I suggest, is to start with a few simple thumbnail sketches. Use these sketches to decide whether the scene will make a good composition, and whether there are interesting qualities of light or other aspects that you can explore and develop.

A Corner of Corfu Old Town
57 x 39cm (22½ x 15¼in)

Drawing and Observation

Observation is an important, integral part of the drawing process. Through observation we gain a better understanding of the subject matter, and consequently we are able to make decisions as to what is special about it and the sort of qualities and effects we need to convey in the drawing. In my view, especially when working *en plein air*, drawing is always concerned with selection and simplification, with expressing the essentials. The ability to see and appreciate the potential in a particular scene is something that comes with experience, of course. In time, artists become attuned to observing and judging things in this way.

Not everything we see is heaven-sent! Whether it is an interior, a landscape or a town scene, the subject before us usually requires some kind of modification to the actual content and arrangement of shapes in order to create an effective painting. So, never be afraid to leave things out or to move shapes around slightly, if this enhances the composition. Adjustments of this type can be evolved in the thumbnail sketches or any subsequent larger drawings. Then you should be able to draw in a much freer and more confident way on the watercolour paper itself.

When I start to draw on the watercolour paper I usually hold the pencil between my thumb and forefinger, at a very shallow angle to the paper surface. I am a firm believer in letting the whole arm move with the flow of the line, so

Location pencil sketch
30.5 x 40.5cm (12 x 16in)

This type of sketch will help you decide the extent of the view that you want to include in your painting and the balance of the composition.

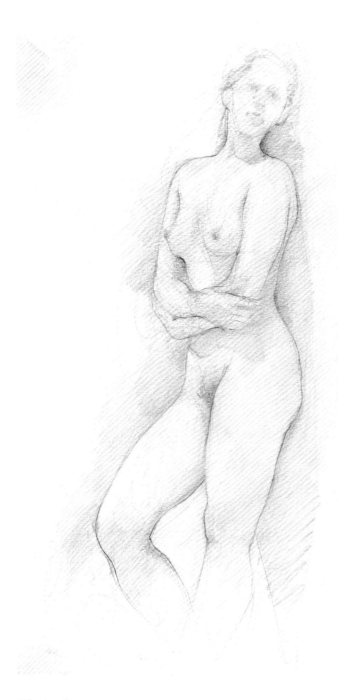

Life drawing
40.5 x 29cm (16 x 11½in)

There is no better way to improve your observation and drawing skills than to attend regular life-drawing classes.

that the movement comes from the shoulder. This gives a great deal of freedom and expression to the marks and lines, which at this stage generally consist of a series of squares, rectangles and circles, which I use to plan the basic composition. I aim for a light, sketchy drawing to begin with, and then I gradually intensify the weight of the pencil lines where necessary. However, I avoid indenting the paper, as I will probably decide to erase all of these lines at the end of the painting. I normally work on Arches paper, which will take quite vigorous rubbing out without resulting in any surface damage. I draw with a 2B, 3B or 4B pencil, depending on the degree of spontaneity and the particular effect that I need. I use a Staedtler Mars eraser in preference to a putty eraser, which in my experience is not easy to keep clean.

If you need to improve your drawing skills I suggest you enrol at your local life-drawing class. Life drawing is such a liberating and pleasurable experience. With perhaps only the sound of charcoal on paper, the atmosphere of diligent study in the life-drawing studio is second to none. Moreover, because of the concern for proportions, form and so on, this is a discipline that is relevant to every type of subject matter. Poor drawing is usually the result of complacency. You have to be prepared to work at it, to rub out if necessary, and never to accept second best.

Sketching Techniques

Sketching is an invaluable part of the working process, and when I was younger I used to do a tremendous amount of sketching outside. Now, relying more on my experience and the fact that, over the years, I have developed a more dependable eye for interesting, challenging subjects, I find that I can often begin straight away on the actual painting. Nevertheless, I always carry a sketchbook, and I still strongly advocate that the best way to get to know a location is to spend some time drawing it, perhaps adding some written notes, as in my pencil sketch on page 46. With any subject, it is

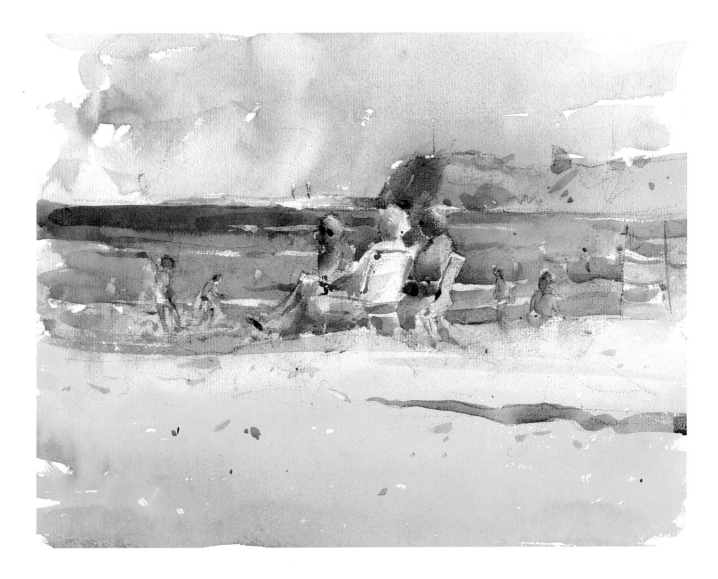

Watercolour sketch
20 x 25.5cm (7¾ x 10in)

This is a typical small *plein-air* watercolour sketch of the kind that I make to test out different ideas, especially those involving groups of figures.

always helpful to start with some small sketches, preferably from different viewpoints, in order to familiarize yourself with what is there and what will make a good painting.

These sketches do not necessarily have to be made in a sketchbook, nor indeed do they need to be very detailed. For example, the initial information for my painting *Piccadilly* (page 30) was a little sketch hurriedly made on a piece of card (actually the protective wrapping around a painting), which was the only surface I had available. I made a small, simple drawing on this to remind me of the general composition, and I added some written notes. Similarly, I often try out ideas by making a few thumbnail sketches on the brown gummed paper strips around the edges of a painting.

Sometimes it is interesting and rewarding to make a drawing just for its own sake. However, usually there isn't time to produce a very complex drawing – and in any case, if the intention is to follow up with a painting of the same scene, it can be unwise to expend too much energy on the preliminary stage. There must be something left to explore and express in the painting. Pencils are good for quick studies and tonal sketches, and pen and wash is another useful technique. Today, there are lots of exciting sketching materials worth trying, including water-soluble pencils and pastels.

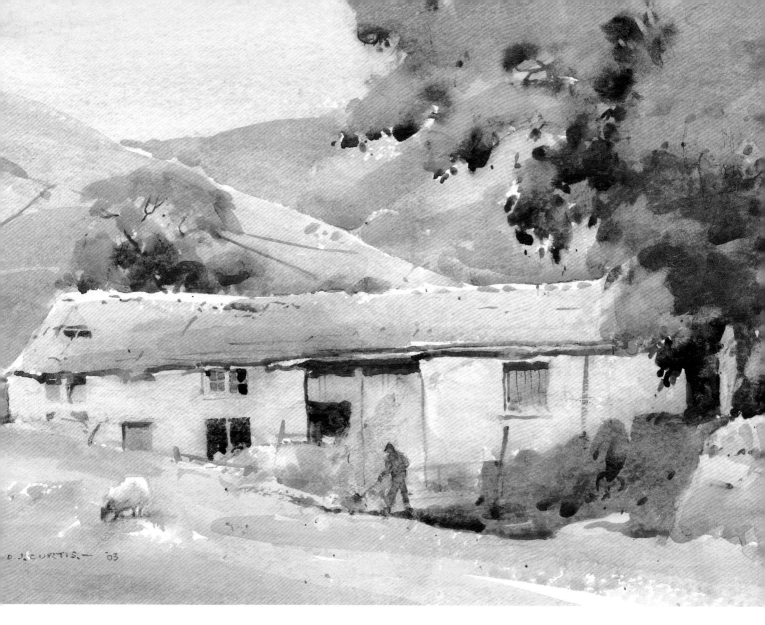

Watercolour sketch

20 x 28cm (7¾ x 11in)

Make fast-and-loose sketches like this to help you get a feel for the
scene and try out different colour combinations and relationships.

Page 50–51 *Filtered Light, Trafalgar Square, London*

 57 x 77.5cm (22½ x 30½in)

Although I had some good photographs and sketches, it took quite a
while for me to pluck up enough courage to attempt this complex studio
painting, which required very careful planning to ensure that the
composition worked effectively.

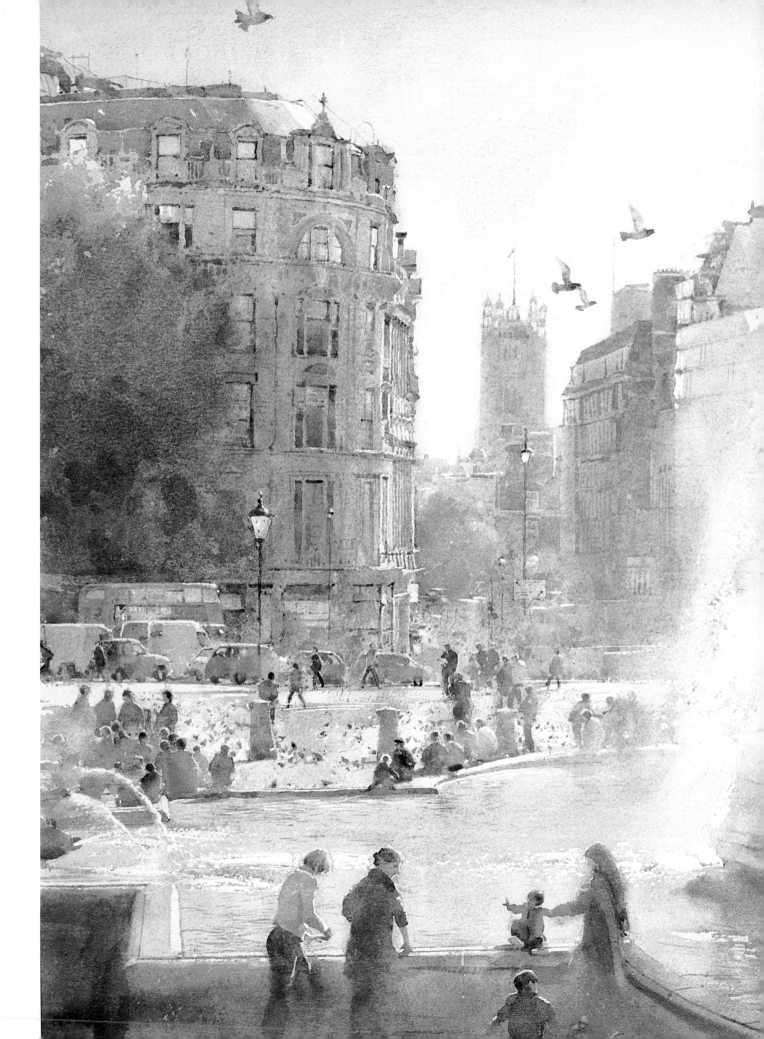

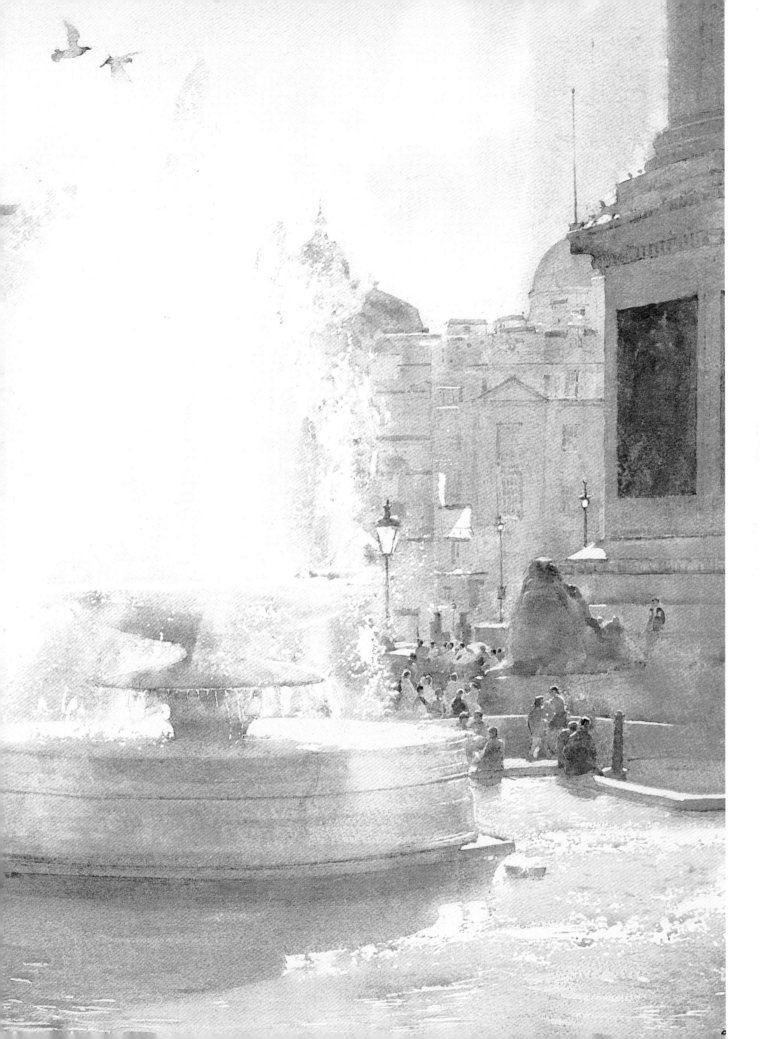

Composition

Drawing and composition are, in a sense, the same thing. As you draw, so you are building with different shapes and creating an underlying structure and design for the subject. It follows that if the shapes are ill-conceived and badly drawn, the success of the painting will be seriously undermined.

Often, the initial perception of a subject is that it involves a complex array of shapes, and so the skill with composition is knowing how to simplify what is there and create some sort of order and harmony. At the same time, the shapes must be used in such a way that they contribute to the originality, interest and impact of the painting. Nothing should be too dominant or too central, I think, and more often than not I find that I am using a composition that closely relates to the Golden Section (the division of a sheet of paper so that the smaller section is in the same proportion to the larger section as the larger is to the whole – the ratio is approximately 1:1.618). In other words, I like to place something significant – perhaps the horizon line, a tree or another vertical feature – about two-thirds of the way up, down or across the picture area, as in *High Viewpoint and Receding Tide* (right). Composition is partly an intuitive process, but I am also conscious of the placing and relationship of the different shapes.

In a good composition there is a rhythm throughout the work, and the shapes and colours are so devised that the viewer's attention is directed around the painting yet kept within its bounds. I like to include little areas of mystery – parts that are unresolved, that just drift away. This adds to the contrast and interest within the painting and gives viewers the opportunity to use their own imagination. While I aim to make my paintings 'read' easily, I don't think everything should be spelt out in detail.

I would advise against putting too much in the corners – instead, tempt the eye into the centre. And while every picture needs a focal point, a key feature of interest, ideally this should be achieved in a subtle way. I like to create some means of leading the viewer into the painting. Z-shape and S-shape compositions work well in this respect, as seen in the painting below.

right *High Viewpoint and Receding Tide*
38 x 29cm (15 x 11½in)

Here, the harbour wall, which I have placed on the Golden Section, makes an interesting foil for the busy foreground area.

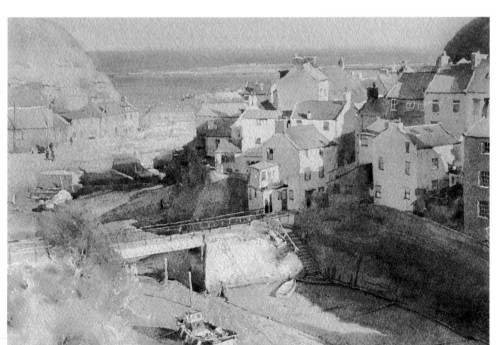

left *From Cowbar, Staithes, Yorkshire*
28.5 x 39cm (11¼ x 15¼in)

Shadows can play a vital part in creating a strong composition, as in this late afternoon scene.

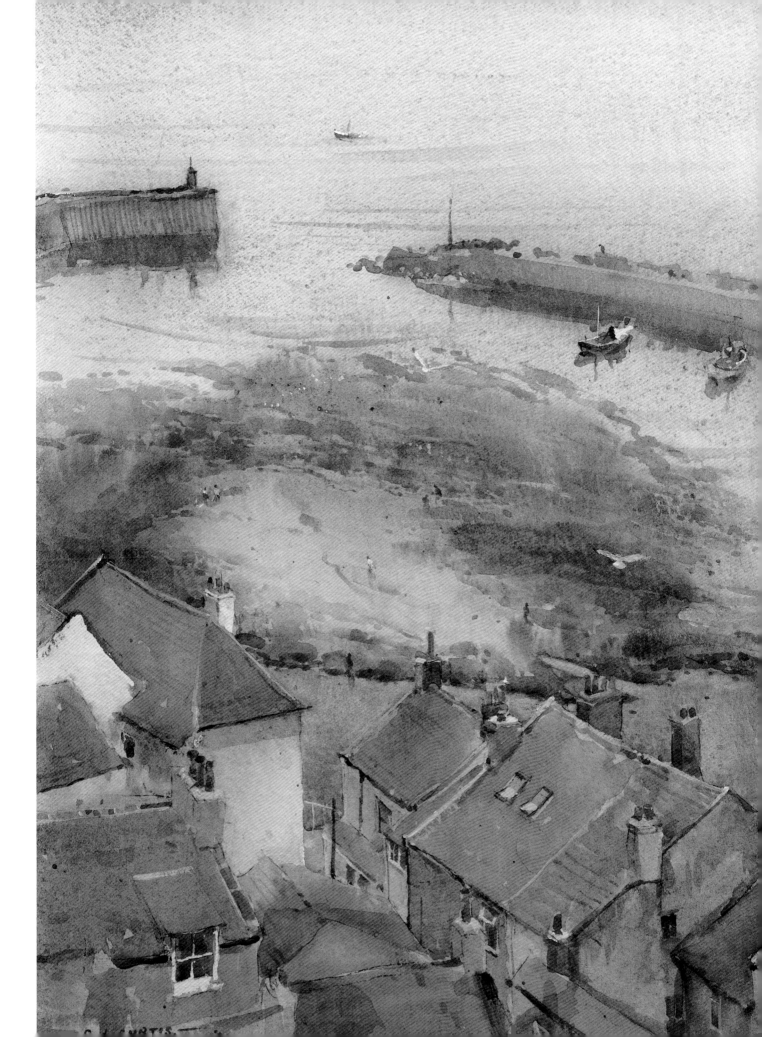

From The Nab, Staithes
57 x 77.5cm (22½ x 30½in)

Again here, it is the lights and darks that energize the composition.

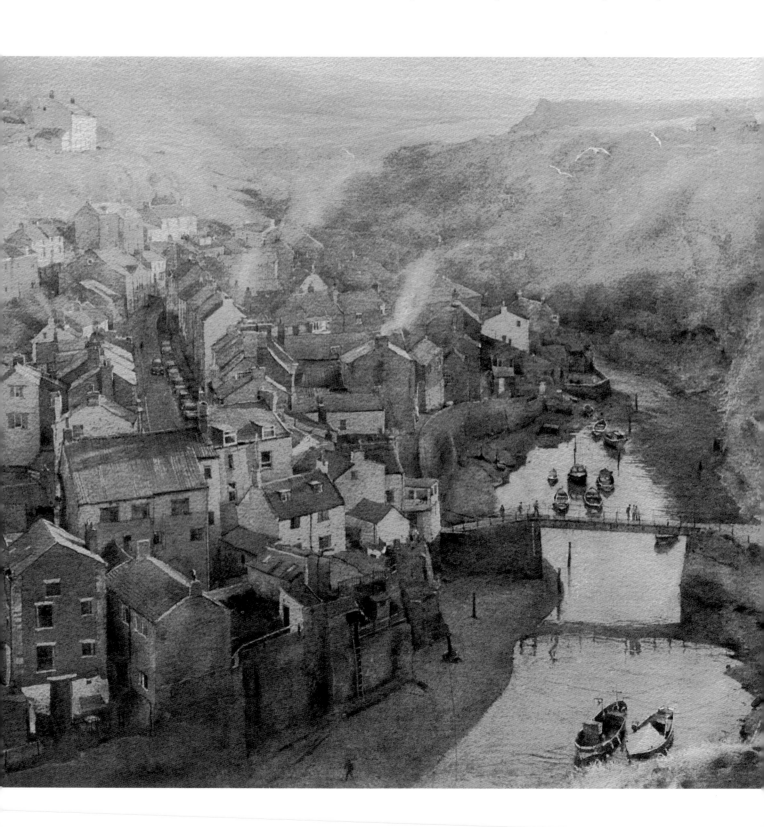

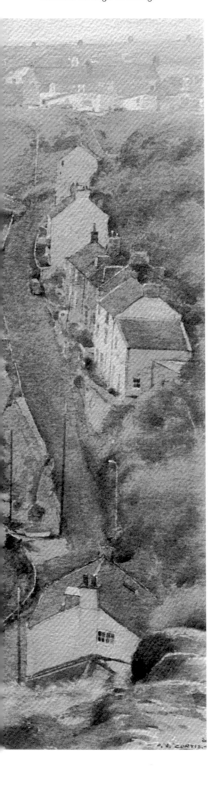

right *Scattered Millstones, Burbage South, Derbyshire*
39 x 28.5cm (15¼ x 11¼in)

I discovered this subject, with its wonderful interaction of tone and shape, in an area where I often go climbing.

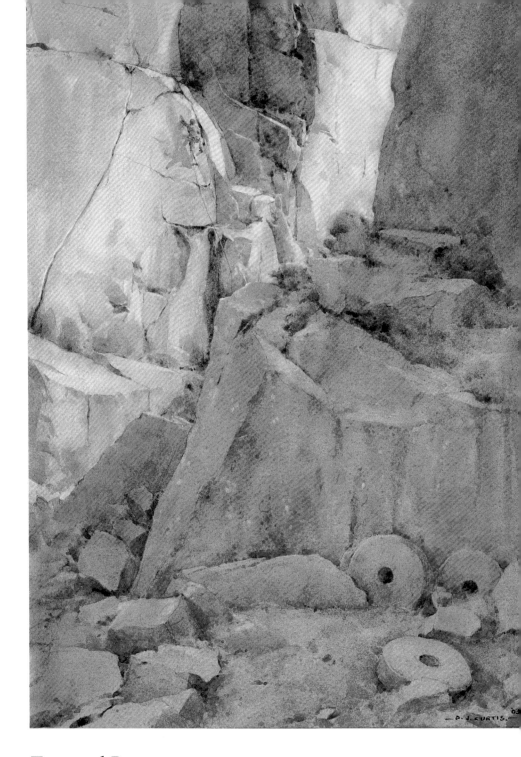

Tone and Pattern

Usually tone and pattern are the two most important qualities to consider when making the first assessment of a subject. The tonal key (that is, whether the general effect is predominantly light, dark or mid-toned) will set the mood of the scene, while the jigsaw relationship of the different shapes will determine the basic composition. Ideally, in both of these qualities there will be scope to create contrasts and variations.

As in *St Ives Foreshore* (page 56), I prefer subjects in which I can detect a degree of abstraction – in which there is a mosaic of shapes that will translate initially into a series of curves, triangles, squares and so on, forming a sound

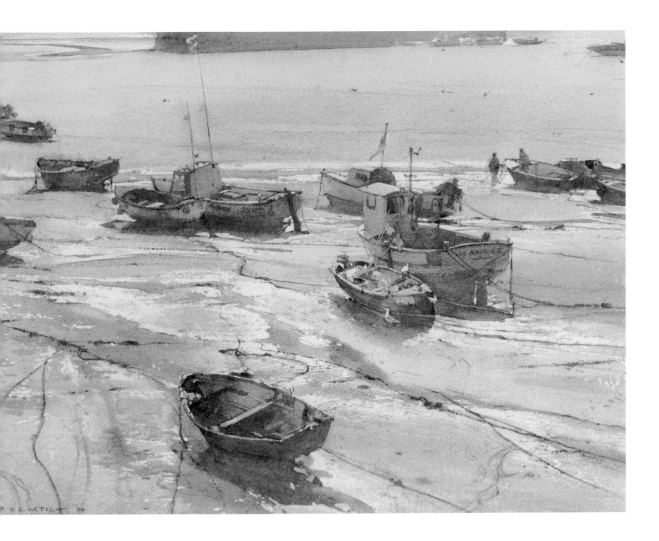

structure for the painting. When at the scene I also note the light conditions and decide whether it is a good time to pursue the idea, or whether it would be better to return later in the day, or perhaps early the following day. It is a question of observing shadows and other effects and judging how these, in conjunction with the potential of the composition, will influence the impact of the painting.

Understanding Tone

I like every subject to offer me something new to express, and it must have a strong composition. After that, it is usually the quality of light that attracts me to the subject, and one of the first things I need to consider is how the type and strength of light determines a particular tonal key for the painting. In some subjects, for example a barn interior, the tonal contrast might be quite limited, and there will be an inherent tonal harmony. Other subjects might involve more extreme variations of tone, and in such cases it may be necessary to adjust some of the tonal values.

In general, tonal contrast is something that I like to leave understated, although when a subject is seen in a low, flat light, pitching the tonal key higher can make an improvement. On other occasions a high key seems to work very well. I seldom paint in the midday light, but I did try this approach for *West Stockwith Basin* (right) which, as you can see, proved to be a fairly high-key subject, even though it is painted *contre-jour*.

St Ives Foreshore, Cornwall
28.5 x 39cm (11¼ x 15¼in)

A subject without a sky, yet in which the nature of the sky influenced the dark tonal pattern of the boats and the contrasting rivulets of light.

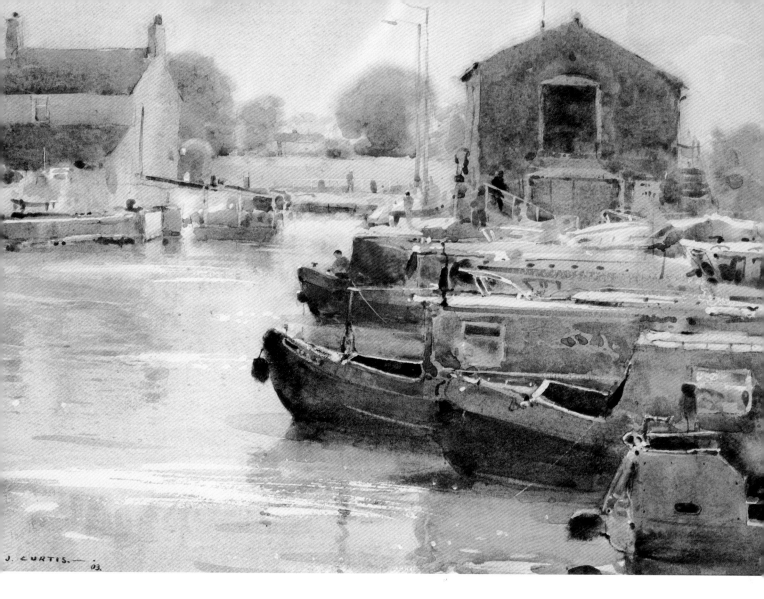

J. CURTIS.—
03.

West Stockwith Basin, Nottinghamshire
28.5 x 39cm (11¼ x 15¼in)

Even in a high-key, midday light, this
scene proved an effective subject to
paint because of the strong tones in
the foreground.

But what do we mean by tone? As well as being a certain colour, every object
has a relative tonal (light/dark) value. It could be extremely light in tone or very
dark, and there is an infinite variety of possibilities in between. Moreover,
because of the influence of light and the way that it plays across the surface of
objects, there may well be changes of tone even within a relatively small area.
This can lead to very complex tonal variations, but here, as in many aspects of
painting, the secret lies in simplifying what is seen – in concentrating on the
essence rather than the detail.

It is important to be able to judge the tonal qualities of a subject, because it
is principally the variations of tone in a painting that help convey effects such as
three-dimensional form, space and atmosphere. Estimating tone can be quite
difficult when you first start painting, but after a while it becomes second nature
to see things in terms of tone as well as colour. A useful technique for judging
tone is to half-close your eyes as you look at the subject. This will help you
focus on tone rather than colour, and give you a better perception of the overall
tonal range.

Tone and Colour

From your assessment of the tonal key for a subject you should be able to choose a suitable group of colours to convey the tonal values you require. Incidentally, these tonal values, in addition to the way they are used to depict form and other qualities, are also important in creating the distinctive sense of light – and consequently the particular mood – of the painting. In fact, of course, colour and tone are inseparable. So, as you gain some experience, when you mix and apply each colour you will automatically begin to consider its tonal value – whether it should be a light, weak colour or something more intense.

The way that I work, beginning with an overall 'ghost' wash to indicate the general shapes and colours within the subject, essentially means that my initial colours are the ones that I will use throughout the painting. I immediately know, when I have completed that first wet-into-wet wash, whether the harmony of colours will work and whether I have chosen the right colours for the intended tonal range. With every wash I will chop and change with the colours – that is, vary the colour and tone to match the qualities that I feel are important in the subject. You can see how I have used this type of variegated wash in *Sunshine and Shadows* (right), particularly across the large foreground area.

Tonal variations with colour can be achieved in several ways. Each colour has an inherent range of tonal values, so that lemon yellow, for example, is naturally a light-toned colour, while French ultramarine is dark. In watercolour, of course, the strength of a colour will also depend upon how much water is added to the pigment. The tone can be adjusted by adding other colours to the initial wash, or varying the proportions of the different colours used in a wash. For example, a mix of viridian and cobalt violet will produce a lovely grey, but the exact tone of the grey will depend on the proportion of cobalt violet to that of viridian.

Colour Harmony

Naturally the overall effect of the colour itself can be an attraction in a subject, and quite often there is just an accent of colour somewhere – maybe a red flag in a harbour scene or some poppies at the edge of a meadow – that will make all the difference to the impact of a painting. But in any case, the choice of colours, and the way the different colour masses and contrasts interact across the picture surface, are always important factors in conveying a certain mood in the painting and determining its degree of success.

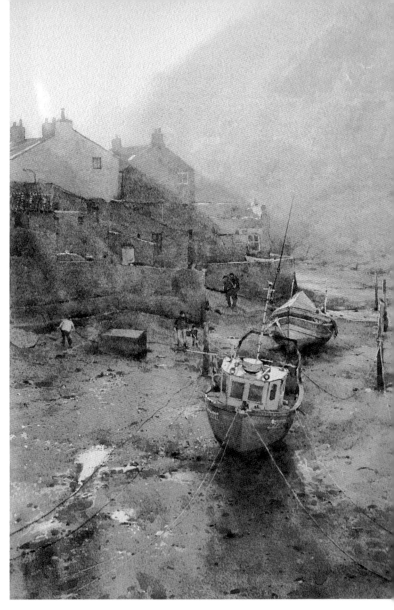

Sunshine and Shadows
57 x 39cm (22½ x 15¼in)

This was a breathtaking light effect that I came across on a misty day in winter, and that I was able to suggest with subtle variations of colour from a very limited palette.

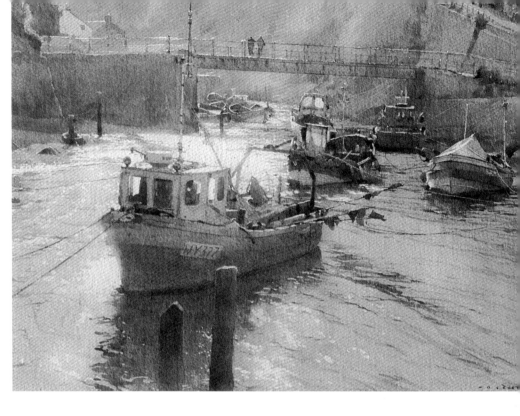

right *River Bed Moorings*
39 x 57cm (15¼ x 22½in)

The challenge here was to capture the drama of the light on the water. Once the masking fluid was in place to protect the light areas, I quickly applied a wet-into-wet variegated wash across the whole of the water area, increasing the intensity of the colour on the right.

below *Welcome Shade, Henley*
39 x 28.5cm (15¼ x 11¼in)

The sense of colour harmony in this painting is achieved by working with a cool, blue/green limited palette.

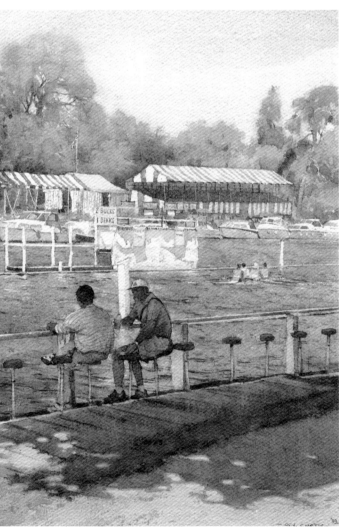

I would describe myself as a tonalist rather than a colourist. Every painting should include a certain amount of variety and contrast, of course, otherwise it will seem very even-toned and unexciting. However, I usually like to work with subdued, harmonious colours, and I am interested in understating rather than overstating, particularly when dealing with vibrant greens in a landscape subject. To achieve this colour harmony I keep to a restricted number of colours (a limited palette) and I like to involve some general unifying washes. See *Welcome Shade, Henley* (left) for an example of this approach.

Observing and Interpreting Colour

The response to colour is obviously something that varies from one artist to another. However, the starting point is always observation – what we notice about the colour and consequently what we feel are the significant qualities to express in our painting. Important too is the fact that, as well as its descriptive role in interpreting the different objects and surfaces that are included in a composition, colour must also work in a technical and physical way within the painting. No colour can be judged and applied in isolation to the rest: every colour has an impact on the overall effect.

If, like me, you are a *plein-air* painter, my advice is to embrace the colours of each season. In early spring, for instance, I enjoy the wonderful contrasts of the green masses of trees, especially when seen in bright sunlight. Although I do not paint these colours in the same high key that they appear in nature, there is nevertheless a lovely

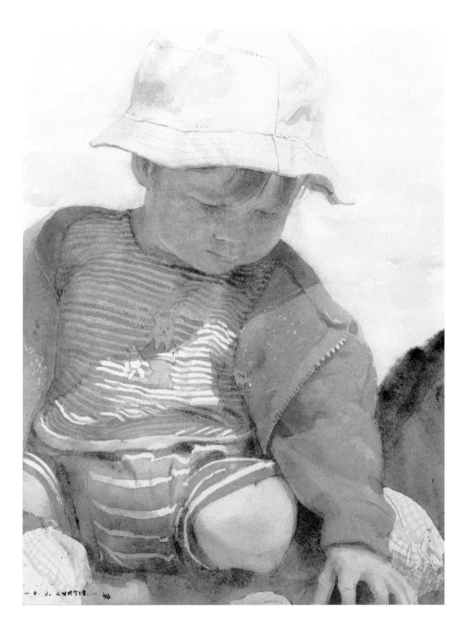

- o. J. CURTIS. - 90

right *Winter Moorings, Staithes Beck*
39 x 57cm (15¼ x 22½in)

With a viewpoint looking down onto the clear
water, one of the problems here was how to
make the rocks and seaweed below the
surface look convincing.

left *Study of Joe*
39 x 28.5cm (15¼ x 11¼in)

What I enjoyed in this painting was trying to
convey the effect of the skin colour in shadow,
and how each part and colour within the
composition links with the others.

visual stimulus and punchy feel to the landscape at that time of the year.
In the winter, by contrast, the colours are much quieter – blues, purples and
gentle greys. With this variety there is always something to inspire me to
go out and paint.

So my motto is: celebrate the colour – but don't overdo it. The fact is that
as soon as you overwork watercolour and lose the transparency, the essential
fluidity and freshness of the colour is also destroyed. That is why, in my view,
painting with watercolour requires a lot of restraint. You have to respect the
medium. It is the reason why I rarely use opaque or body colour – that is for
acrylics or gouache!

Working with a Limited Palette

A limited palette helps tremendously with the control and harmony of colours
in watercolour painting. Although I have 16 colours in my palette, I usually use
no more than six or eight of these – as can be seen in *Winter Moorings, Staithes
Beck* and *Old Stackyard, Gringley* (right), and indeed in the vast majority of my

right *Old Stackyard, Gringley,
Nottinghamshire*
39 x 57cm (15¼ x 22½in)

This is the epitome of my love of old, forgotten
farmyards, and a scene made all the more
exciting by the contrasts of tone and colour.

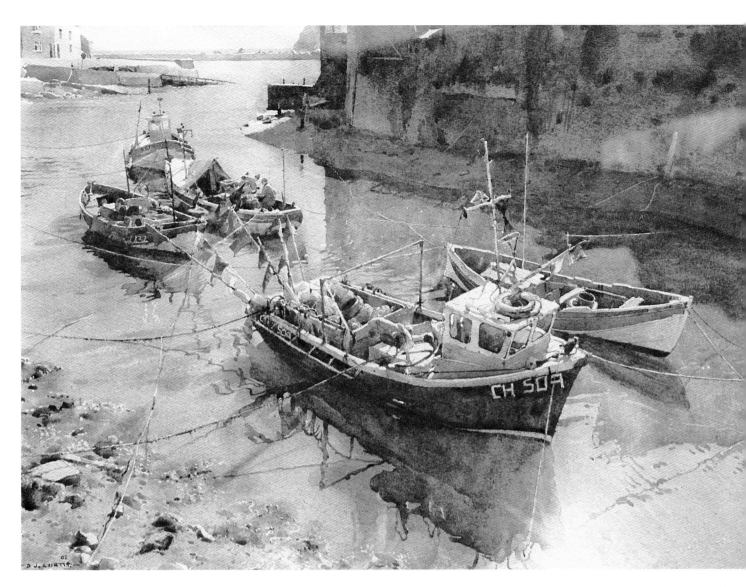

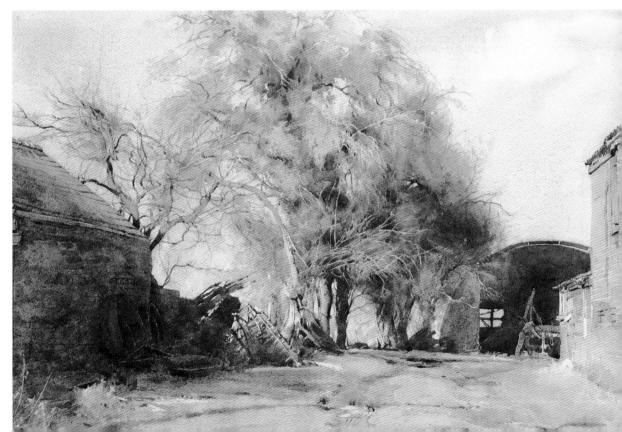

paintings. For example, the palette for *Old Stackyard, Gringley* was cobalt violet, raw sienna, viridian, French ultramarine and cerulean. This is a set of colours that I often use, and when necessary I will add one or two warmer primaries to them, such as gamboge or Indian yellow, and permanent rose or cadmium red.

If you choose the right basic set of colours you will be surprised at just how many different colours you can mix from a limited palette. In fact, rather than being restricted by this limit, you will benefit by improving your skill in colour mixing. Many of the paint boxes sold for watercolour painting include 30 colours or more, which is simply unnecessary and confusing.

Little French Corner
28.5 x 39cm (11¼ x 15¼in)

A fascinating subject that someone drew my attention to, I felt that this was a scene that would be best interpreted with a limited range of colours.

Colour Mixing

Another advantage of using a limited palette is that it reduces the temptation to combine more than two or three colours in a mix, and consequently the resultant wash is kept fresh and transparent. If you start adding all sorts of colours – which may be difficult to resist if there is a large selection to choose from – then most probably the final colour will be muddy and opaque. There are two general points that I think help with colour mixing. Firstly, keep the mixes simple – never more than three colours. And secondly, whenever possible use what I would term 'quiet primaries' for the initial variegated 'ghost' wash. Suggested colours for this are cobalt blue, cobalt violet and raw sienna.

Some colours are more challenging to mix than others. Greens are an example. They can easily become much too vibrant and dominant. For a lovely grey/green I generally use a mixture of raw sienna and French ultramarine. If I want to make this slightly more green I add a touch of viridian, while for a yellowish green I add some aureolin.

French ultramarine and burnt sienna is a good combination for the darks in a landscape. These colours can produce an intense dark in the right proportions, but one that remains transparent. For greys, which are probably my favourite exploration into mixing, I rely on different mixes of cobalt green, viridian, cerulean and cobalt violet. It is possible to make a wonderful range of warm or cool greys from these colours.

Jetty Moorings, Mystic Seaport, Connecticut

39 x 57cm (15¼ x 22½in)

The most challenging aspect of this *plein-air* painting was in capturing the fluidity of the reflections through the subtle use of colour washes.

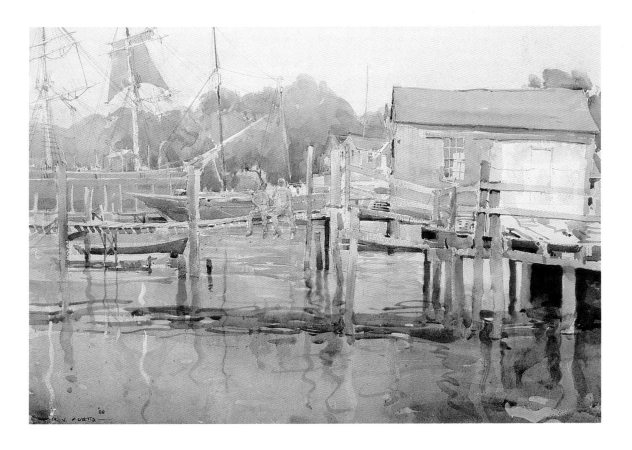

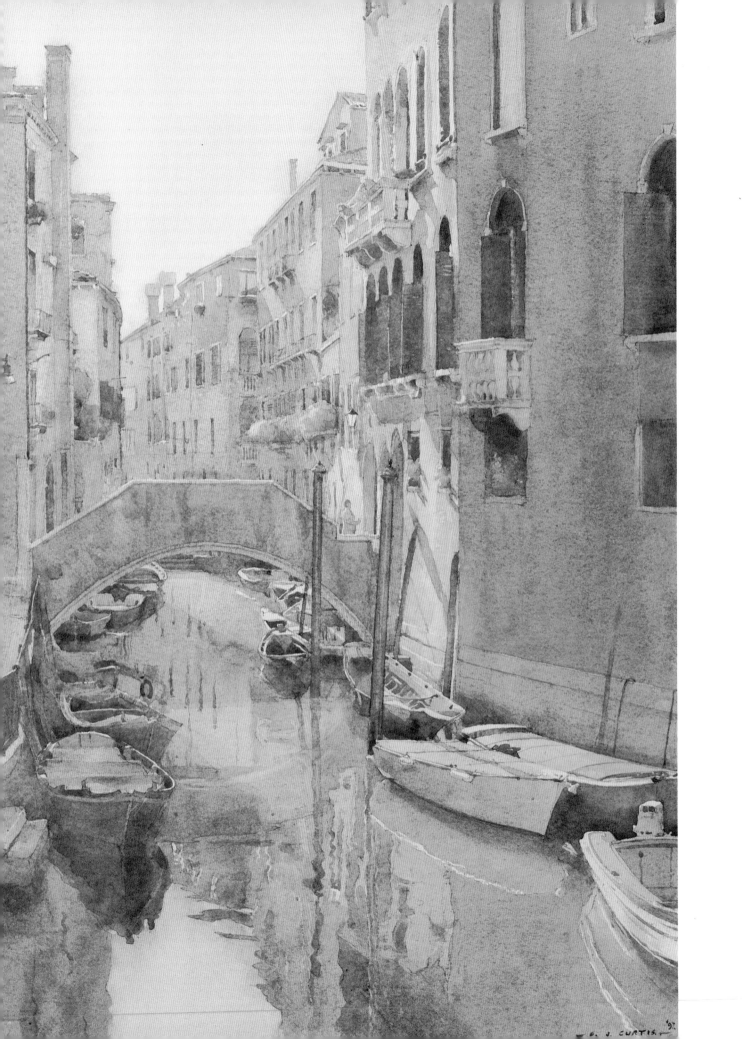

3 Inspired by Light

For me, irrespective of the qualities that a subject offers in terms of content, strong composition, interesting textures, harmonious colours and so on, the attraction is often heightened by a certain light effect. Light can add the 'buzz' factor; it can infuse a subject with a magical quality that is irresistible. However, I also appreciate that light is a transient quality and that this can sometimes cause practical difficulties. Especially in cloudy and changeable weather conditions, what at first appears to be an exciting light effect may soon disappear, and even on a fine summer's day cloud can bubble up and the light can come and go. When painting outside you have to be ready for this and quickly decide whether the subject is more interesting in a flat light or when brightly lit. Again, success relies as much on observation as on painting skills, and in time, experience and memory will also play an important part in capturing different light effects in a convincing way.

Light and Mood

As illustrated in *Practice Night* (below) it is light that energizes a subject and gives it what I would call a certain 'beat', and a distinctive mood and atmosphere. When painting outdoors, light effects can vary enormously, of course, according to the seasons, the particular time of day and the weather. Exploring the scope of these effects is something that I greatly enjoy in painting.

left *Bridge on the Rio Marin, Venice*
 57 x 39cm (22½ x 15¼in)

right *Practice Night*
 39 x 57cm (15¼ x 22½in)

Whatever the type of light – in this case a combination of artificial light and natural, diffused light from above – always try to use it to the greatest effect.

Pages 66–67 *The Slipway, Padstow, Cornwall*
 39 x 57cm (15¼ x 22½in)

Here is another scene that was inspirational because of the drama of light and shade, but much depended on having the discipline to include only the part that was absolutely necessary to create the most effective composition.

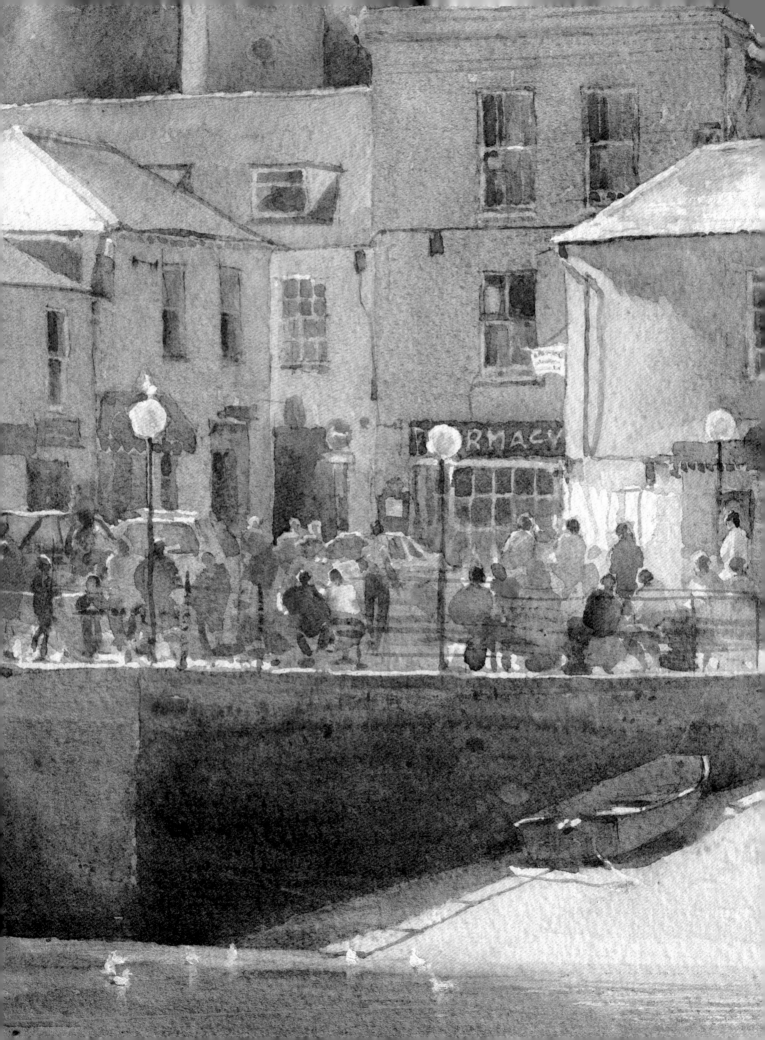

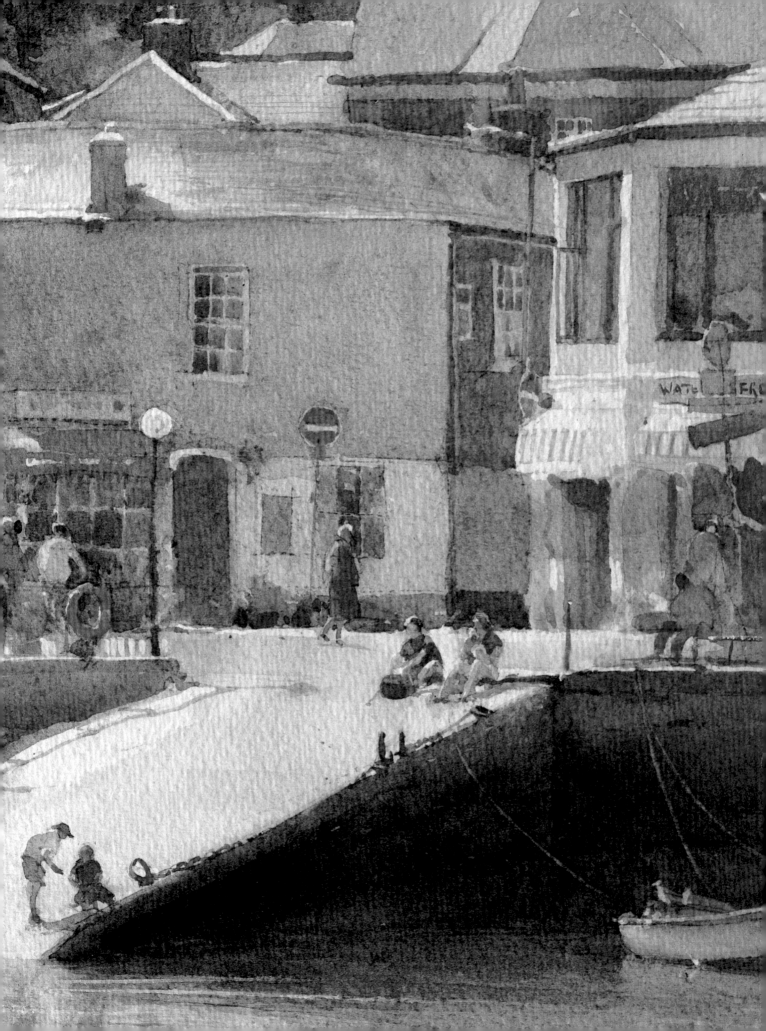

I like to paint in all types of light, but especially when I can work *contre-jour* or when there is a half-light, with the sun just breaking through the clouds. In both of these situations there is an opportunity to embrace the true strengths of watercolour by using simple, lyrical shapes and bold, wet-into-wet washes with lost-and-found edges.

The Drama of Light

In strong light conditions the colours are enriched, and there is plenty of interest and contrast between the lightest parts of the subject and the darkest shadows. In these conditions the light also accentuates the form of different objects, and we are presented with a much clearer idea of depth and space. Subjects such as *The Slipway, Padstow* (pages 66–67), in which the light focuses on certain areas and creates a drama of light and shade, are naturally exciting. But this is not to say that painting outside on a dull day, in a low, even light, cannot be equally challenging and appealing.

In fact, it is generally far easier to paint something dramatic and inspirational, because if it is exciting you are bound to approach it with some verve and enthusiasm. It is much more difficult to extract the maximum impact from a scene that is painted in a flat light. Nevertheless, you should not be deterred from subjects that are lit with an even light, especially if there is a strong, original composition. It is a matter of using some imagination and licence. I often aim to create a sense that the light is just emerging. This enables me to intensify foreground areas, making the tonal values bolder than they actually are. Then, to add to the contrast, I also reduce the tones in the far distance.

So, scenes that are bathed in strong sunshine and incorporate interesting shadows aren't the only ones to offer the best subjects for painting. Like other aspects of painting, interpretation is a key factor; the light effect may need exaggerating, or it may need simplifying. But light will always add drama and impact. It is up to you to determine the extent of that impact.

Capturing a Sense of Place

Working on a cloudy day, when there is a dull, even light, has the advantage that there is more time to produce the effects you want. Even so, it is best not to relax too much or get too comfortable – painting is all the better for some tension and pressure, I think! Due to the fickle nature of light, time will always be limited to a certain extent, no matter how settled the conditions appear initially. Especially when the weather is changeable, or there are important shadows to consider or other fleeting effects, you will need to work very quickly.

When painting something as difficult as the transient quality of light, and working within the time constraints that are synonymous with it, how do you successfully convey those effects to produce a painting that evokes a particular sense of place? What you should not attempt to do is 'chase' the light – in other words alter your painting to match the light effect as it changes. For example, the sun may suddenly disappear, and with it the wonderful shadows that you were hoping to include.

right ***Burbage South and the Hope
Valley Road, Derbyshire***
57 x 39cm (22½ x 15¼in)

The appeal of this subject was the contrast between the dark and mysterious sense of the quarry workings in the foreground and the sunlit landscape above.

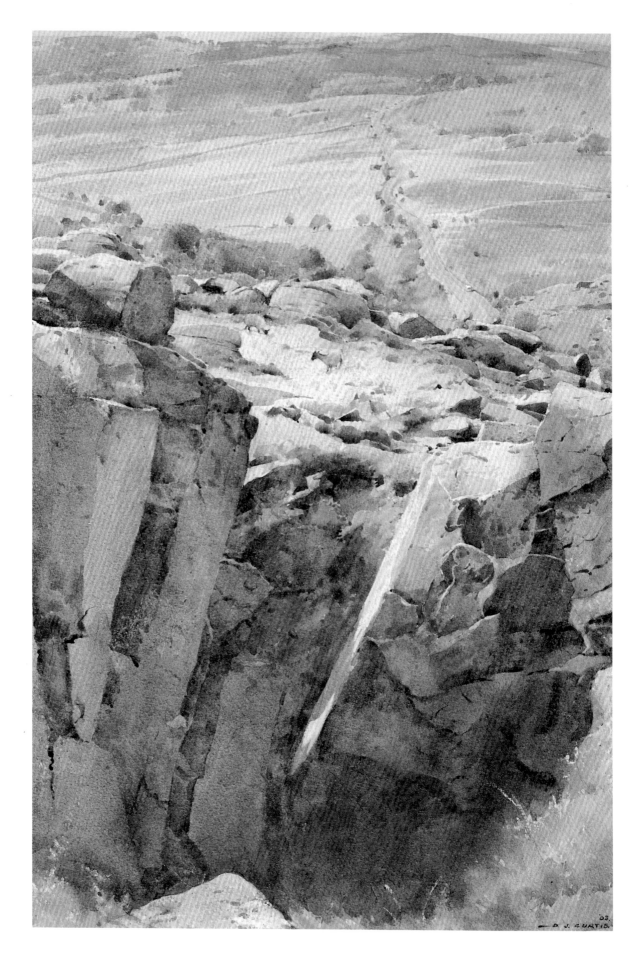

Instead, it is best to start by carefully looking at the subject and deciding on the particular light and mood effect that you want to express in the painting. Most likely this will be the effect that initially drew your attention to the scene and inspired you to paint it. To help fix that effect in your mind and give you some kind of reference, it is a good idea to make one or two simple tonal sketches concentrating on the principal shapes and tones – light, medium and dark. These will give you an indication of the balance between light and dark areas, and from them you can decide whether the composition will work on a larger scale.

Once you have started the painting, focus on your aims for the work and do not be deterred by any variation in the light. To do this, it also helps if you can establish the main lights and darks fairly quickly, early on in the process. If the light changes and you see other possibilities for the subject, you can always make another painting later on, as I did in *Winter Shadows on the Beck* (above).

Winter Shadows on the Beck
39 x 57cm (15¼ x 22½in)

The challenge of painting subtle, extending shadows over a surface of shallow water is something I always enjoy.

Light as a Subject

One of the fascinating things about light is how it can transform an indifferent subject into a scene full of incident and interest – and indeed vice versa! The changing light throughout the day can dramatically alter the look and impact of a subject, in effect producing a number of different painting ideas as the day wears on. A subject seen in early morning light, for example, will look quite different from that viewed *contre-jour* later on.

When you know a coastal area or a particular landscape really well, you get

right *Fond Memories of My Old
Sunbeam Motorcycle*
28.5 x 39cm (11¼ x 15¼in)

Notice how the careful observation of
lights and darks helps in creating the
impression of three-dimensional form.

to understand how it is influenced by various types of
weather and light. Consequently, after a while you will be
able to pick the best time of day and the right conditions
to paint at a certain location. Other subjects may be
opportunistic, in the sense that you come across them
quite by chance, in circumstances not likely to be repeated,
as with *Street Vendor, New York* (pages 72–74). Also, there
will be occasions when you notice a potentially exciting
subject but realize that it will be even more appealing at a
different time of the day or when there is a stronger or
weaker light effect.

It is always interesting to paint the same subject in
different lighting conditions, which of course was an idea
that intrigued artists such as Monet. However, as I have
already discussed, inevitably there is a time limit when
painting outside. If you cannot finish a subject in one
session of about two or three hours, and it is not
something that you can complete in the studio, then the
best solution is to return, if possible, at the same time the
following day.

left *Cottage Backs from a Steep Hill Rise*
39 x 28.5cm (15¼ x 11¼in)

Often it is a matter of waiting for the right time
of day in order to catch a subject in the most
dramatic light.

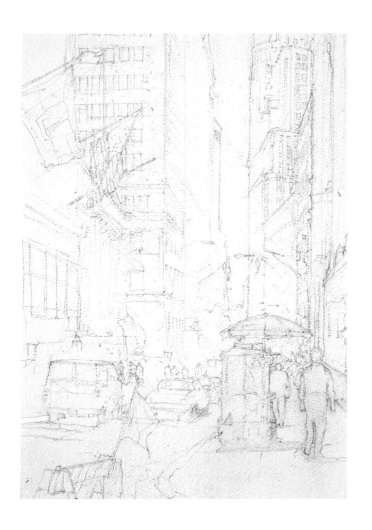

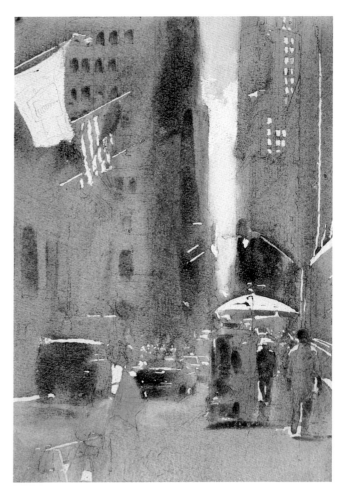

STAGE 1

Street Vendor, New York

Working with reference to the original location photograph and tonal sketch, I began by making a more considered drawing on a sheet of stretched watercolour paper. I also applied masking fluid to protect the extreme light areas.

STAGE 2

Street Vendor, New York

I usually start the painting stage with an overall, variegated wet-into-wet wash to indicate the basic tones and colours. In this painting the wash was more controlled than usual, because I wanted to avoid certain large areas, such as the sky and the flag, that had not been protected with masking fluid.

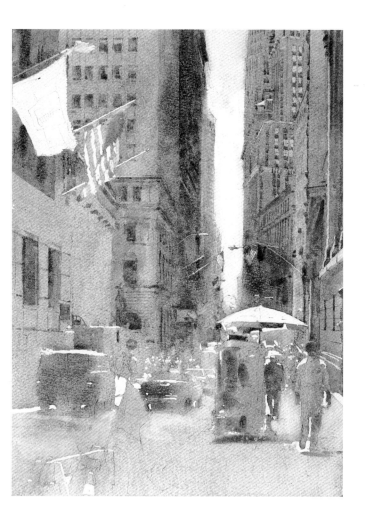

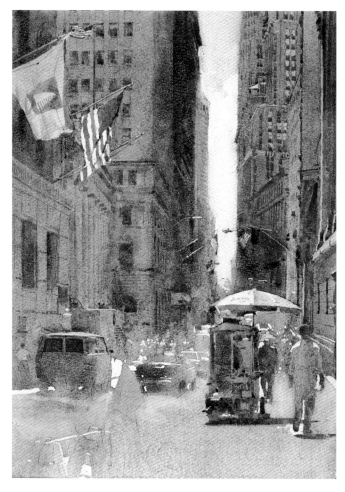

STAGE 3

Street Vendor, New York

Here, I am concentrating on the strength of tone and definition on the right-hand side. Additionally, I knew that this would give me a tonal value from which I could judge the subsequent tones.

STAGE 4

Street Vendor, New York

At this stage I decided to make a slightly sharper contrast between the foreground and the buildings, particularly with regard to the ice-cream seller.

Page 74

STAGE 5

Street Vendor, New York
39 x 28.5cm (15¼ x 11¼in)

Finally, I completed the foreground detail on the left and slightly intensified the darks here and there. The difficulty when painting huge buildings such as these is that the numerous windows can dominate the composition. The answer is to subdue them in tone and so keep them as part of the overall block of buildings.

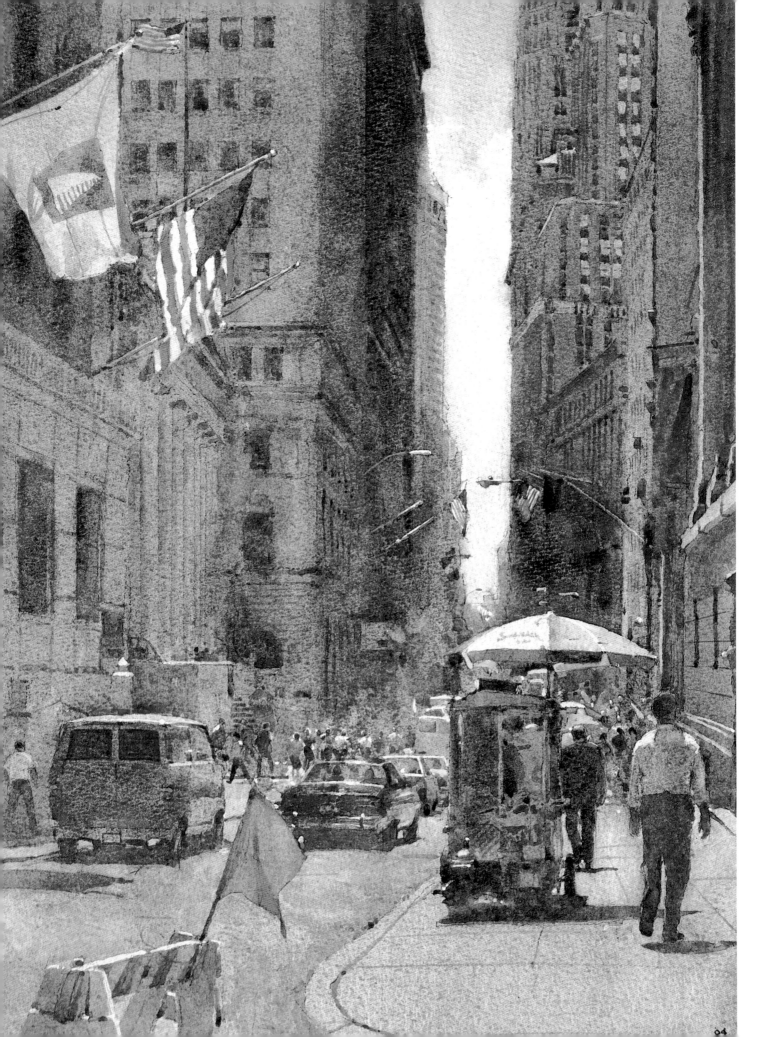

04

Morning Light

With the sun low in the sky, the advantage of morning light is that it gives good, strong foreground shapes. These can be used to create an effective 'cushion' for the subject in the lower part of the painting, and so direct the emphasis onto the drama and quality of the light above. Also, much can be made in the morning of cast shadows as an important aspect of the composition, whereas by midday these shadows will have receded and the tonal contrast will be far more extreme. Another benefit of starting early in the day is that you are more likely to be fresh and alert, and thus more sensitive and responsive to the special atmosphere of the scene.

I recently painted in Paris at 9 o'clock in the morning. The atmosphere was amazing. Some of the buildings were in complete shadow, others had just their tops lit by the emerging sun. For this type of subject I usually work on a small scale, starting with a few pencil lines to indicate the main areas of the composition. Then I quickly add the preliminary overall variegated wash, which I let dry slightly before working into the darks with some brush drawing, considering any local colour that could be useful, and developing the counterchange of light and dark shapes. Speed is essential in situations like this, and you need to be very observant and decisive. *Harbour Moorings* (pages 76–77) is a good example of the light effects that are typical with morning light.

right **An Orkney Dawn**
28.5 x 39cm (11¼ x 15¼in)

Early morning light is often incredibly exciting, creating transient scenes such as this, which make perfect subjects for a watercolour painting.

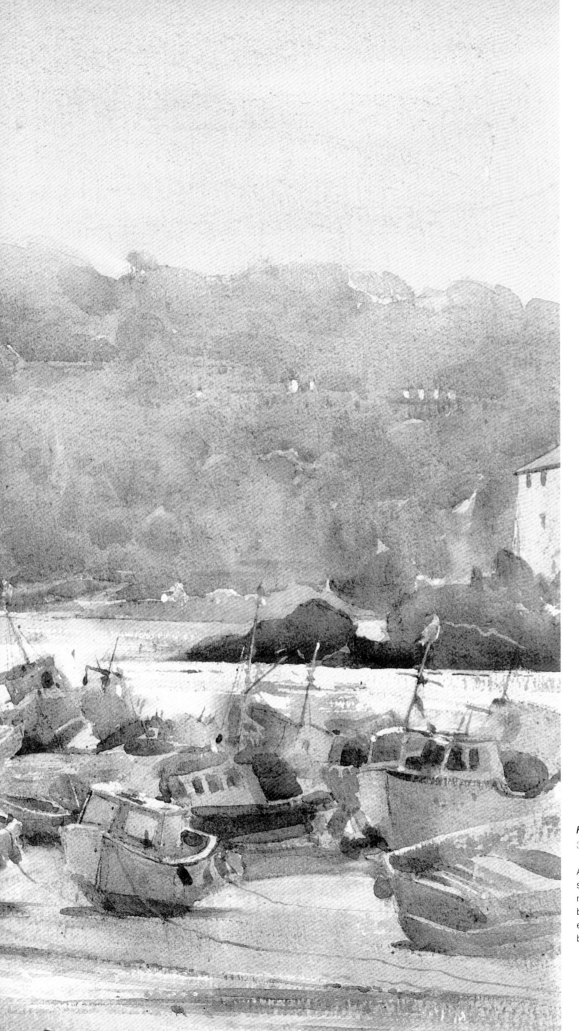

Harbour Moorings
39 x 57cm (15¼ x 22½in)

Another wonderful
subject seen in the
morning light – this time
bright sunlight – which
encouraged a loose
brushwork approach.

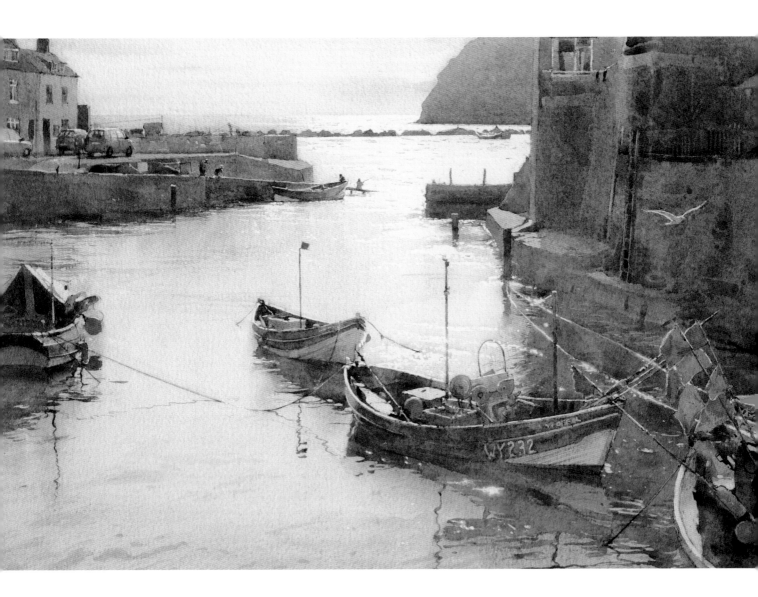

Contre-jour

With *contre-jour* the viewpoint is directly into the light, so the main elements of the subject are seen in silhouette or partial silhouette. Usually the colour is low-key with high-key accents and details. For me, *contre-jour* is all about crispness and softness, using strong shapes but contrasting them with little nuances of light and detail here and there. Where light meets dark, the edges will subtly blend together, and for this effect I normally use a wet-into-wet technique. In areas that have more insistent darks, I generally find that a dry-brush technique works best.

Because the significant features of a *contre-jour* subject are simplified by the effect of light, it is even more important to consider the composition carefully and ensure that the idea works as a whole when using this technique. Note how in *High Spring Tide, Staithes* (above), for example, there is a balance of darks formed essentially by two large blocks, left and right, interrupted in places by the various small light shapes that are repeated across the subject, adding further unity to the design.

Flat Light

As discussed in Capturing a Sense of Place, the main advantage of flat light is the time factor: there is a reasonable consistency in the quality of light over a longer period of time. This allows a more considered approach to the subject, which for me means a greater emphasis on drawing.

I love drawing, and if I find a subject with potential as far as the composition and drawing are concerned, then I welcome the chance to work on it for a good length of time and really get involved in the detail. Typically, interiors such as barns and boatyard workshops make excellent subjects for this kind of approach, although *Tall Ships in Charlestown Harbour* (page 80) is another interesting example. Here again the rigging provided an opportunity for some detailed drawing.

Other Light Effects

Something else to be aware of is reflected light, and particularly how this influences the tonal values within shadows. If you look carefully at a shadow you will probably find that it isn't the same dark value all over; usually there are subtle variations that add to the interest of the shadow area. I often check this by making a circle with my thumb and forefinger, which I look through as I move it across the shadow area, noting where there are any changes of tone. Incidentally, this is also a useful technique when painting the sky and water areas of a subject.

Studio lighting is, of course, mainly artificial. It is a form of lighting that many artists use, especially for interiors, portraits and life painting, and still-life compositions. The advantage of artificial light is that it is very controllable – you can fix the direction and intensity of the light, and this will be consistent for as long as you wish. However, what you must avoid, I think, is a light that is too yellow, as this makes it extremely difficult to judge colours accurately. If you work a lot in the studio, try to ensure that you use only the special fluorescent tubes and bulbs you can buy that produce the full frequency range of natural daylight. This is essential for allowing you to judge colours as accurately as you would in sunlight.

Highlights and Shadows

In addition to assessing the tonal range within a subject, another important point to consider is the actual placing and distribution of the lights and darks, because this is an aspect that has quite a bearing on the effectiveness of the composition, and therefore the ultimate success or failure of the painting. The things to check are the source and direction of the light, the general balance of lights and darks, and whether you need to simplify certain light effects, for example the numerous light patches that show through the foliage of trees.

Light is always a quality that watercolourists have to keep in mind throughout the painting process. Normally the first step is to isolate, or 'reserve', the lightest areas of the subject; thereafter everything depends on developing

left *High Spring Tide, Staithes, Yorkshire*
39 x 57cm (15¼ x 22½in)

Potentially complex, this scene was made simpler, and in fact more dramatic, by the *contre-jour* effect, which created a stark contrast between the dark shapes of the boats and the brilliance of the water.

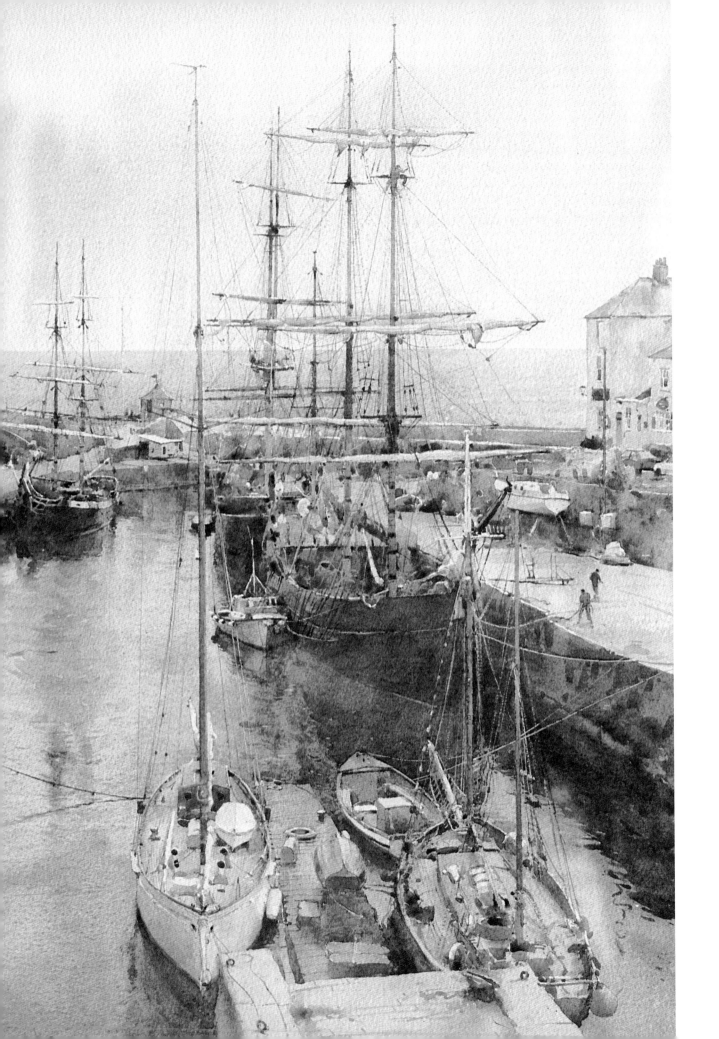

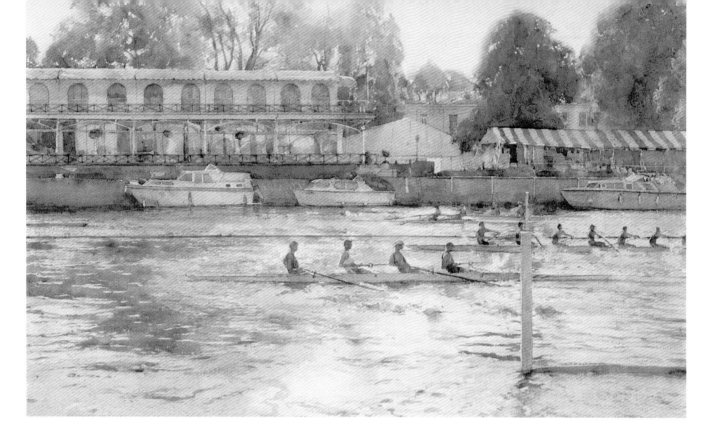

above *Hot June Evening, Henley*
39 x 57cm (15¼ x 22¼ in)

It is always the quality of light that creates a particular mood for the subject, in this case the warmth and stillness of a late evening in summer.

left *Tall Ships in Charlestown Harbour, Cornwall*
57 x 39cm (22½ x 15¼ in)

This was a very considered studio painting which relied initially on careful observation and accurate drawing.

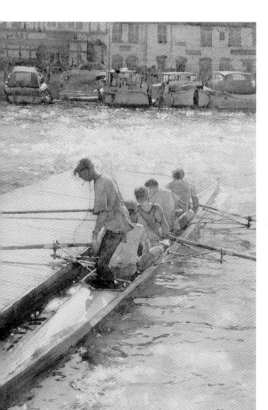

Qualifying Day I – Henley
39 x 28.5cm (15¼ x 11¼ in)

For the sparkling light effect on the water I started with touches of masking fluid. Later, when the masking fluid was removed, I wetted these areas with some clean water and added a very small amount of cadmium orange, allowing this to fuse into the surroundings.

the right tonal relationships. If a light effect is overworked or lost, it is usually irretrievable. Lifting out, overpainting with body colour, and other techniques can be used to re-establish a certain light effect, although inevitably they will compromise the transparency that is the true nature of watercolour, and so are best avoided.

Working Light to Dark

I nearly always begin by drawing on the watercolour paper to plot the main elements of the composition and to determine the shape and placing of the highlights and any other areas that I think should be left as white paper. As I have already implied, it is best not to overplay the numerous little patches of light that are found in some subjects, so I squint hard at the scene to help me simplify what is there and determine which areas of light are the most important. Where it is possible to work the washes of colour around a large 'white' area (in fact it may be slightly tinted with colour later on), I will simply leave it as white paper. However, in most paintings I use masking fluid to reserve the whites and highlights, as explained on page 39.

Rather then filling in the drawn shapes very precisely with the masking fluid, I like to apply it in the same way that I would place the lights with impasto in an oil painting – by using free-flowing,

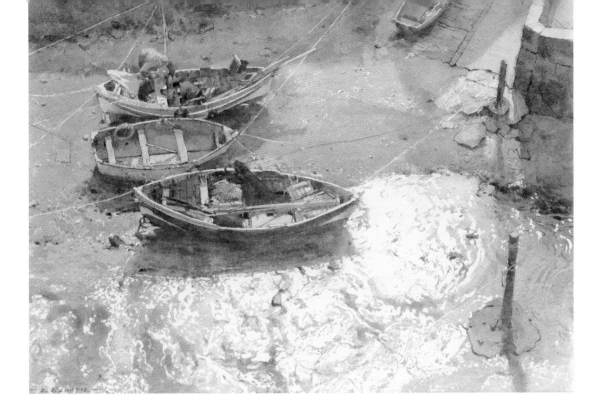

vigorous brushstrokes. This helps ensure that the masked-out areas are more in keeping with the rest of the painting; otherwise they can look too defined and obvious. Having reserved the lights and placed a middle tone where appropriate, I quickly indicate the extreme darks. This completed, I have then set some parameters for the painting: the basic drawing and structure of the composition, the reserved light areas, and now, with an initial wet-into-wet wash, a reference for the mid-tones and darks. While I need to maintain a disciplined approach and keep in mind where I want to develop certain contrasts, textures and other effects, from then on the process should be easier for having defined these boundaries.

Hard and Soft Edges

The play of clearly defined shapes and outlines against those that are more subtle or diffused can be an effective and important feature in a watercolour painting. Counterchange – the placing of light shapes against dark, and dark shapes against light – is a useful technique for enhancing the impression of light and creating a sense of space and movement. One of the greatest challenges in painting, of course, is how to convey the impression of depth and three-dimensional form on a flat sheet of paper.

Invariably areas that have been reserved with masking fluid will have a crisp outline. You may want to keep this, for example where it defines the side of a building, or alternatively you could soften it with a wet brush or sponge. The other point about hard and soft edges is that they add contrast and interest, and indeed, where shapes are not so defined, a sense of intrigue in a painting. See *The Victoria Memorial* (right).

Shadows and Composition

Shadows contribute to the overall sensation of a certain type of light, and they can also be an important linking feature within the composition, as demonstrated in *Crisp Morning Light on the Yorkshire Coast* (page 84). But you

Moored Boats in a Bright Light
28.5 x 39cm (11¼ x 15¼ in)

The challenge here was to suggest the transition of light and colour across the surface of the water.

right *The Victoria Memorial, London*
57 x 39cm (22½ x 15¼ in)

This proved a wonderful exercise in the use of tonal counterchange – light shapes against dark, and dark against light.

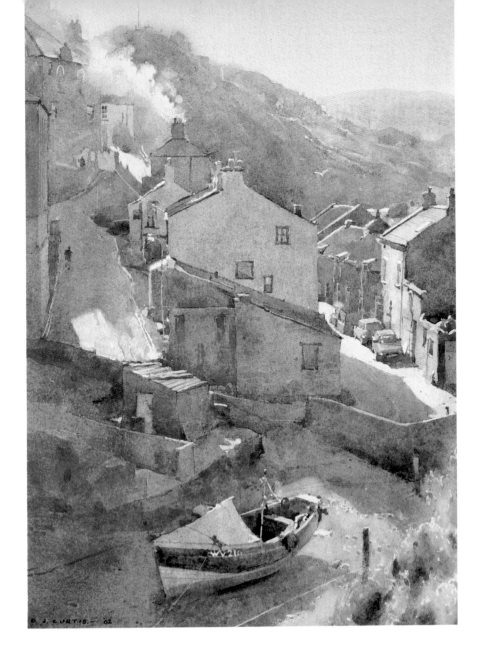

left *Crisp Morning Light on the Yorkshire Coast*

39 x 28.5cm (15¼ x 11¼ in)

In this scene I have used the smoke trails to break up the form, and to help create a sense of rhythm and dynamism in the composition.

do have to be careful about the shape, strength and direction of shadows because, if they are overdone, shadows can so easily work in a dominating and counter-productive way, rather than a positive one.

I like to consider shadows as an integral part of the design, and I am not afraid to play their impact down, or up, as the case may be. They can be particularly useful in the foreground, to add interest and lead the eye into the painting. Often the shape of a shadow is thinner and more linear and harmonious than you would imagine.

The Colour of Shadows

I often see paintings that are spoilt by the inclusion of shadows that are too insistent, either in tone or definition, or sometimes both, and my advice is to avoid colours such as Payne's grey and Vandyke brown when painting them. Shadows are seldom one colour all over, so your aim should be to look for the variations of colour within them. You can do this using the same finger-and-thumb technique that I explain above for checking different tonal qualities (see

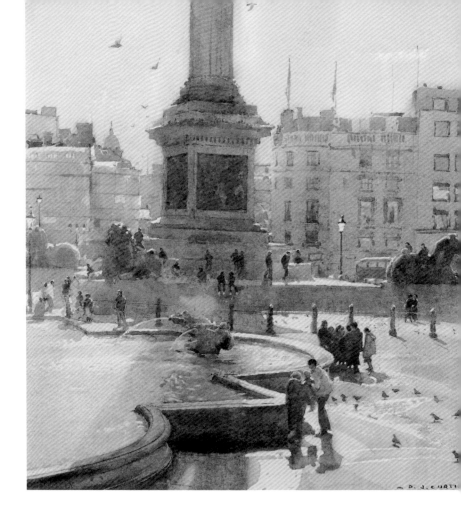

right *Autumn Light, Trafalgar Square*
 39 x 28.5cm (15¼ x 11¼in)

Notice how the shadow of Nelson's Column
becomes slightly diffused over the water area,
and then darker and more defined.

below *Elegant London Façade*
 39 x 57cm (15¼ x 22½in)

Again, notice how the strength of the shadow
colour is influenced by the surface on which
it falls.

page 79). Notice too, as in *Crisp Morning Light on the Yorkshire Coast* (page 84), that while foreground shadows might be quite sharp, those in the distance are usually much softer and more diffused in outline.

There are several other points about colour that are worth noting. First, the colour is usually a bluer or a purple/blue version of the colour of the surface on which the shadow falls, as in *Autumn Light, Trafalgar Square* (page 85). A common mistake is to use a completely different mix of colours to those used for the actual object. Also, the colour of a shadow will vary slightly as it crosses different surface textures and tones. Look at the main shadow in *Elegant London Façade* (page 85), for example, and notice how it changes in tone when it meets the white area of the building.

Page 86-87 *Polperro Harbour In the Afternoon Light, Cornwall*
39 x 57 cm (15¼ x 22½in)

This wonderful view of Polperro Harbour is at its best in the late afternoon. At other times it is rather complex, yet without the drama and the colour harmonies that occur when the sun is beginning to drop towards the west.

Painting in All Weathers

Whenever you paint outside, the weather will have some influence on your choice of subject matter and the techniques and effects that you decide to use. In fact, very often it plays a significant part in determining what and how you paint. The weather itself can be inspirational. Who could not be moved by the sight of clouds scurrying up a valley, for instance, and the dramatic, changing effects of light this produces on the undulating landscape below!

Capturing the fleeting effects of weather successfully is very difficult, and in my opinion is only possible after much experience. To understand the weather you need to work outside as often as you can, and in all kinds of conditions. Try not to rely on photographs. The best way to develop an appreciation and a knowledge of the weather is to make numerous sketches. Start with pencil or charcoal if you wish, but additionally some quick pastel or watercolour sketches will prove very useful for colour reference.

No painting inspired by the weather can ever be truly accurate, simply because you cannot paint fast enough to capture what is usually only a momentary effect. Therefore your painting has to rely on a combination of factors: what you observe at a given moment in time; what you can remember about the scene; and other appropriate effects and ideas added from your memory and imagination.

Practical Considerations

I have painted in a temperature of 38°C (100°F), and that was quite a test. However, the biggest problem is always the wind. It is not so much that it rocks the easel, for usually this can be remedied to some extent. More annoying is the way it buffets your body and unsteadies your hand, making it extremely difficult to produce fine strokes and subtle effects. I sometimes overcome this problem by working from my estate car. It was even better when I had a camper van!

Rain is another problem. Spots of rain can severely damage a watercolour painting. So, if it is damp or raining, I work under a big umbrella – the sort that people use when fishing on a riverbank. Also challenging in damp conditions is the fact that the paint dries very slowly. On the other hand, when it is either drizzling or actually raining the light is usually low-key and quite settled, and

consequently there is more time to develop particular effects, especially with wet-into-wet techniques.

The only time that I need to speed up the drying process is after I have applied the masking fluid. Then, I take the painting to the car and dry it with a small fan that I plug into the cigarette lighter. In contrast, when the weather is extremely hot the paint dries very quickly. In these conditions it is essential to have generous amounts of paint ready mixed and to work speedily, wet-into-wet, with liberal washes of colour.

Seasonal Variations

I work on location at all times of the year, and there are examples in this book of subjects painted in different seasons. The period from November to early spring is my favourite time. While I enjoy the summer I nevertheless find the dominance of greens rather overwhelming and, with tall grasses and lots of vigorous undergrowth, the form of the landscape is often lost. I tend to paint at the coast in summer and early autumn, when similarly the high-key colour is not ideal for my usual palette, which is fairly subdued.

The winter, with its skeletal trees, better defined landscape forms and features, and more subtle colours, offers the subjects and challenges that interest me most. I do not mind working in the cold. Summer can be a bit too comfortable, I think, and this can encourage complacency. A situation that creates more edge and demands more fight and nervous energy is better for me and certainly better for the paintings.

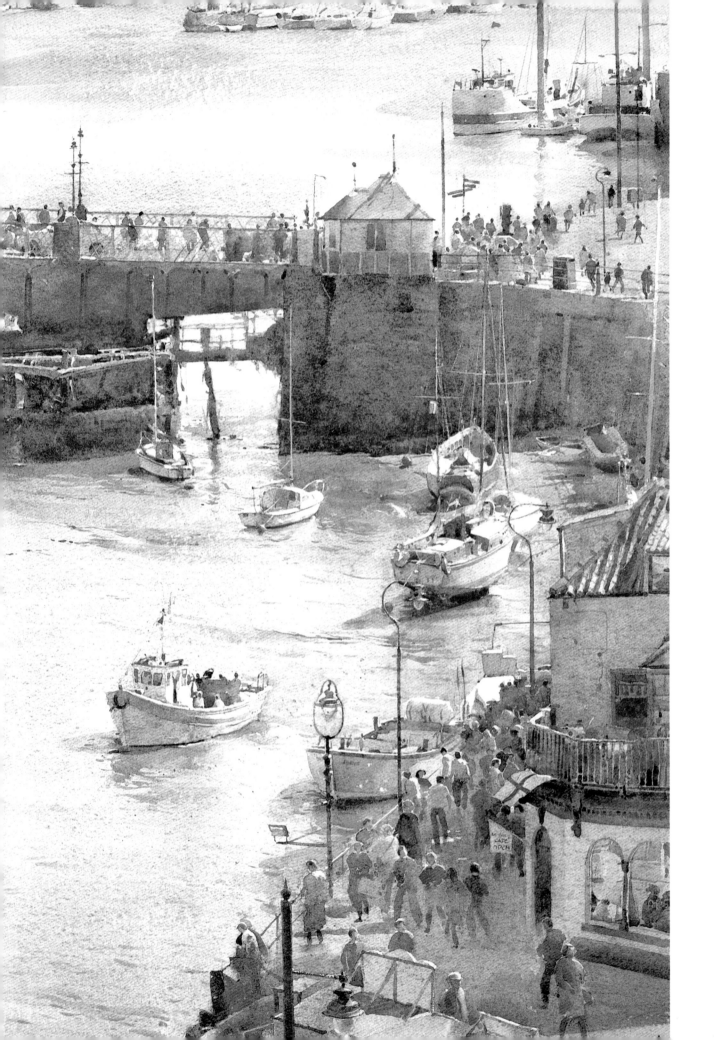

4 Subjects and Interpretation

Watercolour painting is a complex business, and there are always many different factors to consider. Naturally I hope that my observations, advice and paintings will help you as much as possible in this respect, but above all, I hope this book is successful in stressing and demonstrating two very important aspects of the watercolour medium – its particular qualities of fluidity and transparency, and also its versatility. The fact that watercolour is an ideal medium for capturing the transient effects of mood, atmosphere and light makes it suitable for an immense range of subject matter.

I paint many different subjects, including beach and harbour scenes, people, landscapes, interiors and buildings. I am a great believer in variety. New subjects provide fresh challenges and help keep my work interesting and forward-looking. It would be easy to concentrate on subjects such as beach scenes, which I know will sell well, but I delight in trying new ideas. In my view what is always important is to paint subjects that first of all appeal to you, spark a desire to paint, and then, however difficult, offer something original and demanding to work on.

To maintain your motivation and development as a painter over a long period (I have been painting seriously for about forty years), you do need to chop and change with both subject matter and media. For example, quite often I start the day by painting in watercolours and then, after an hour or two, when the light has changed, I switch to a different subject in oils. That change, from transparency to plasticity, is very effective in keeping me aware of the distinctive qualities of each medium and how I can exploit those qualities. Without the stimuli of different subjects and media, there can be a danger of complacency, leading to rather tired-looking results.

View from the West Cliff, Whitby, Yorkshire
57 x 39cm (22½ x 15¼in)

Evaluating Ideas

There is a good deal that is intuitive and instinctive about choosing subjects, and experience is also an important factor. Now, after many years' experience, I rarely have to search for subjects – they seem to present themselves. But while my assessment of an idea is much sharper and more refined than when I started out, I still ultimately hope to find the same 'factor of three' qualities that I looked for when I was younger. These three qualities are appeal, composition and tone. So, having found a subject that you like the look of, my advice is to consider it in terms of strong appeal, good composition and interesting tonal values. If, additionally, it has an exciting light effect, so much the better.

Sometimes subjects offer more potential than is initially apparent, and it is a matter of finding the best viewpoint. Try looking at the subject from different positions. A few feet to the left or the right may make a tremendous difference to the composition and overall impact of the scene. Similarly, check whether the best viewpoint is from high up, as in *Aunty Pat's Cottage* (left), which usually gives a greater emphasis on pattern, or low down, as in *Old Stackyard with Geese, Brampton-en-le-Morthen* (below), which enhances the sense of drama. Obviously you need to choose a spot that enables you to paint safely and without interruption, so often the viewpoint is a compromise between the ideal and various practical considerations.

Before you start painting, other points to assess are the light and weather conditions, and the complexity of the composition. Does the weather look as

left *Aunty Pat's Cottage*
39 x 28.5cm (15¼ x 11¼in)

Although I could not find a satisfactory viewpoint at street level from which to paint this commissioned subject, from the nearby hillside all was revealed!

below *Old Stackyard with Geese, Brampton-en-le-Morthen, Yorkshire*
28.5 x 39cm (11¼ x 15¼in)

I especially enjoy painting farmyards, but it is rare to find one as unspoilt as this. Here, I took as low a viewpoint as practicable to add drama to the composition.

though it will change radically in a short while? If so, it may be better to come back later. As for the composition, how well do the principal elements within it fit together to create something visually exciting? Making some thumbnail sketches may help you to judge what to put in and what to leave out. Do the main shapes make a satisfying design? Be aware of weak areas, particularly in the foreground. As discussed on page 52, try to ensure that the interest is kept within the picture area, and that there is a sense of movement around it. See also Foreground Interest (page 111).

Boats and Boatyards

There have, of course, been changes in my approach to *plein-air* work over the years and, as I have discussed, I am constantly seeking fresh challenges in my choice of subject matter. However, as a general observation, I would say that the subjects most likely to appeal to me – perhaps neglected old barns, landscapes with a pattern of fields, hedgerows and stately trees, or sailing barges and other interesting boats – are becoming increasingly difficult to find. I suppose it is due to modern farming practices and the growing demands on the landscape for housing, roads and commercial development, but I am certainly aware that there are now far fewer scenes in which there is a natural, ready-made sense of design and an inherent, interesting play of shapes, colours and textures.

Perhaps this is why I am attracted more and more to coastal locations. In places such as Staithes, in North Yorkshire, which I visit frequently, there is a greater likelihood that I will find subjects with the potential for sound drawing, strong composition and the other qualities that I like to develop in a watercolour painting. I have always loved the shape of boats, and what I also like

Fishing Cobles on a Shingle Beach
28.5 x 39cm (11¼ x 15¼in)

Half-light on objects creates a wonderful sense of form. In this scene I also liked the way that the horizontal shaft of light was countered by the vertical support for the bridge, giving a lovely T-shaped design.

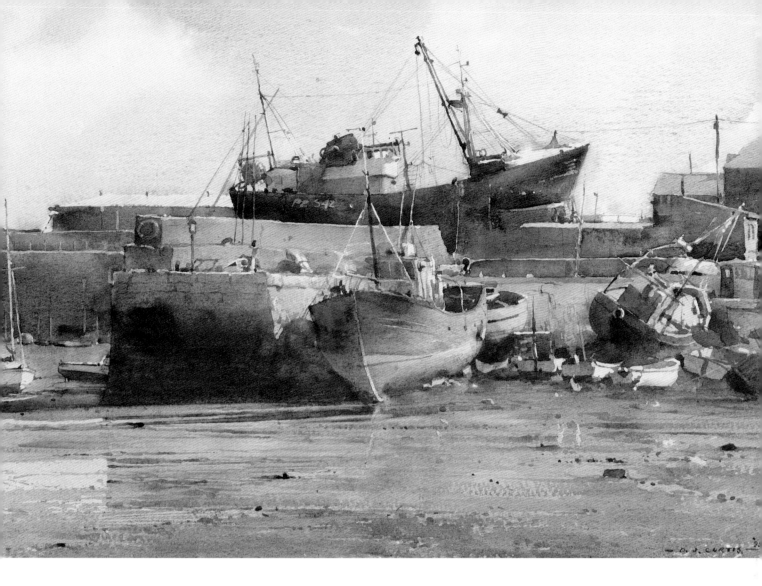

The Harbour, Newlyn, Cornwall
28.5 x 39cm (11¼ x 15¼in)

There is a much greater sense of the structure of a vessel when it is seen out of the water.

is how they create an exciting, punctuating feature within a general view. Often, the way that boats lie in the water, catch the light and give purpose to reflections is inspirational. Look at the groups of boats in *Fishing Cobles on a Shingle Beach* (left), for example.

The structure of boats is something else that I have always found interesting. I particularly enjoy painting subjects such as *The Harbour, Newlyn* (above), where the boat is out of the water, making the entire structure visible. I am also a boat owner, which I am sure is an advantage, as my knowledge and understanding can help inform my work.

Sound Drawing

The first essential when drawing boats, as indeed with any subject, is careful observation. Check all the angles and proportions and, with these in mind, draw some faint pencil guidelines on your paper to construct an initial three-dimensional trapezium shape into which the boat will fit. Then, working from this basic skeletal shape, you should be able to plot the outlines of the boat quite accurately. The main points to be aware of are to avoid elongating the shape, to check the relative proportions of height to width and the width of the beam, and to take care over ellipses and curves. See my pencil sketches of boats on the next two pages.

Often, when you see boats in a harbour, estuary or river location, there are far too many to attempt to represent in a watercolour painting – and in any case, aiming to reproduce exactly what is there seldom works as an effective approach to composition. Often at Staithes there may be some thirty boats, and I will want just six of them. So, you have to be disciplined about selecting the boats that will give you the most effective arrangement. At the site for *Fishing Cobles on a Shingle Beach* (page 94) for example, there were more boats than I have shown in the painting, including one jutting into the right-hand corner. Where I decide to leave a boat out, I simply regard the space as part of the background and relate it to the surrounding area – perhaps an extension of the shoreline, or more of the harbour wall.

Interesting Details

Rigged sailing boats are particularly exciting and challenging subjects, and occasionally I like to concentrate on painting an individual boat of this type. However, even if I have chosen to paint just a single boat, I still want it to be part of a marine scene that creates an exciting composition. What I try to avoid is painting a boat 'portrait'. With this kind of subject the result can so easily become very illustrative and look like the sort of image that you would find on a box for a kit-form model boat, instead of a painting. One way of preventing this is to devise the composition in such a way that most of the boat is included, but not all of it, as in *The Endeavour Approaching Whitby* (right). This produces a more personal, painterly feel to the work.

I use a similar approach for details, such as the rigging in *Sparkling Light near Kassiopi, Corfu* (right). Again, it is a matter of being selective. If every detail is carefully painted, the effect can be very rigid and illustrative instead of creating a real feeling for the subject and a sense of light and movement. Of course, some well-defined lines are necessary, but not too many. Where there are highlights, for example, it is a good idea to use the lost-and-found technique (see page 31).

I choose the appropriately named rigger brush for rigging lines, masts and other details, selecting a size to suit the thickness of line that I require. I work the stroke upwards, often using a dry-brush technique.

STAGE 1

Boat
Pencil Sketch, stage 1

STAGE 2

Boat
Pencil Sketch, stage 2

above *The Endeavour Approaching Whitby, Yorkshire*
39 x 57cm (15¼ x 22½in)

Try to avoid painting a boat 'portrait'. Even when painting just a single boat, think of it as part of a marine scene that makes an interesting composition.

right *Sparkling Light near Kassiopi, Corfu*
28.5 x 39cm (11¼ x 15¼in)

Particularly with a more complex subject such as this, it is important that the boat is carefully observed and well drawn.

Pages 98–99 *Canalside Moorings, Thorne, Yorkshire*
28.5 x 39cm (11¼ x 15¼in)

Here, I loved the way that the warmth of the late evening light was reflected on the boats and in the water.

The stroke can be varied (lost-and-found) according to the pressure applied on the brush. If a line is too long or too thick it can be washed out quickly with a wet brush or sponge and, when dry, repainted as required.

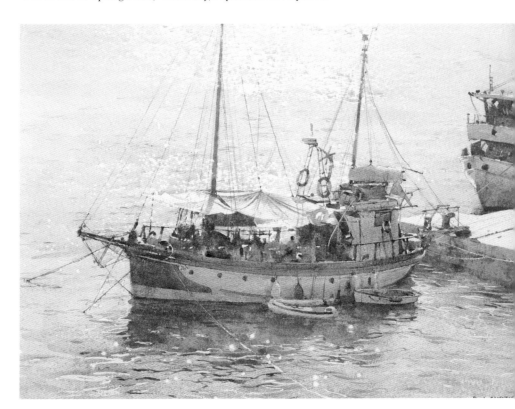

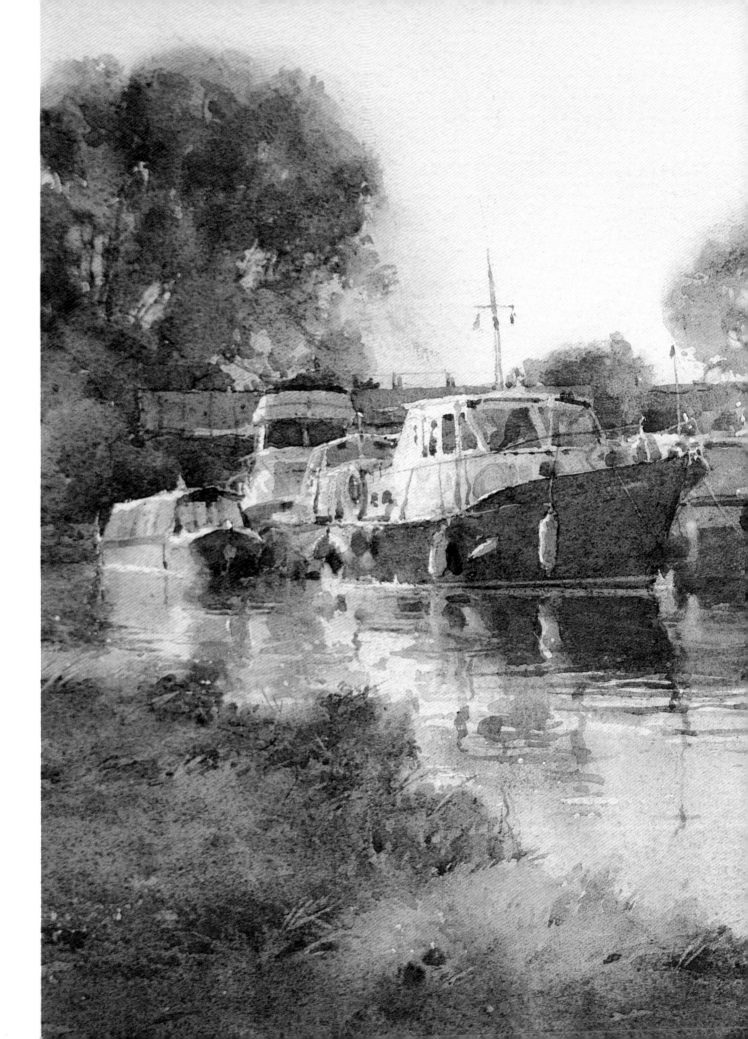

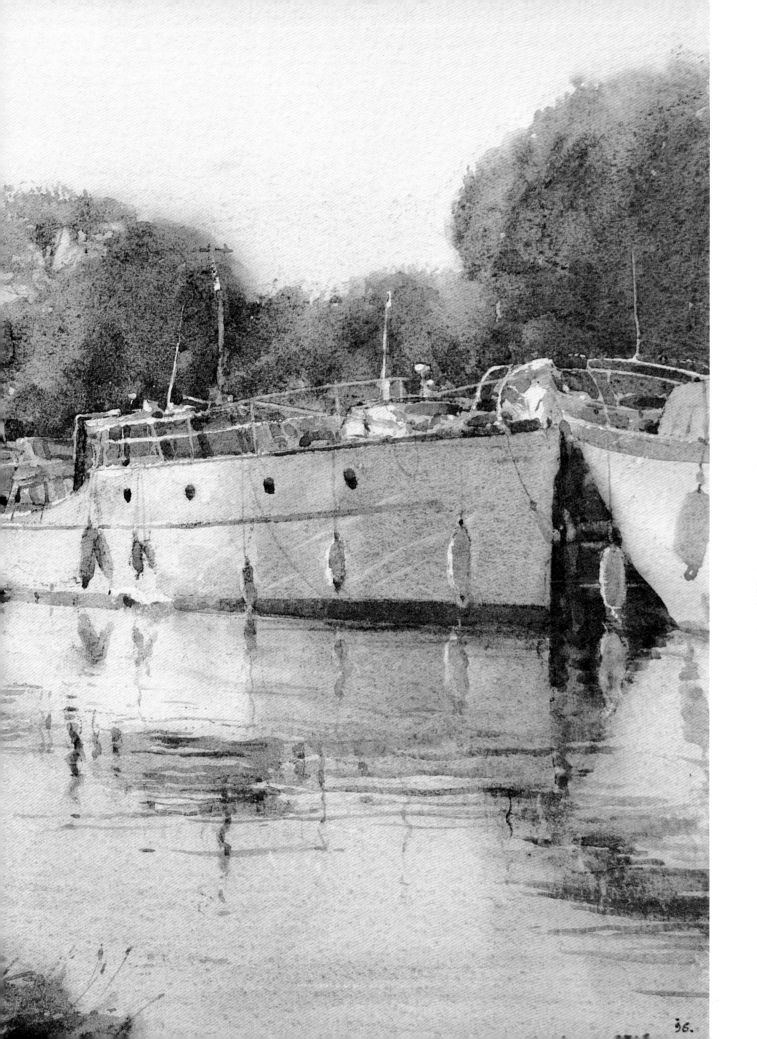

96.

Harbours and Estuaries

The weather, light and other factors all conspire to make painting outside difficult enough, but with harbours and estuaries there is the added problem of the tidal ebb and flow. Generally I choose subjects that I can paint while the tide is going out, so the water level is falling and any boats will be left stranded on the mud flats or sand. In this situation the boats will remain in a certain position for some time. As an added advantage, I also like the light effect that you see on the wet shore at low tide, and the rivulets of water that run across it. These create wonderful directional features to use in a composition, as in *Late Summer Evening, Abersoch Harbour* (below).

If you can overcome the difficulties of painting at harbour and estuary locations, I am sure that, like me, you will find they are places that offer immense potential for original, exciting compositions. Such paintings do not always succeed, but when they do they are certainly worth the extra effort involved. As I mentioned on page 93, when painting outside it is essential to start by assessing the conditions and formulating a plan. Finding the best viewpoint is another important factor. For *Late Summer Evening, Abersoch Harbour*, for example, I discovered that the subject was much more exciting from the top of the bridge than when viewed from the mud flats below.

Late Summer Evening, Abersoch Harbour, Wales
39 x 28.5cm (15¼ x 11¼in)

Don't be afraid to make use of the natural surface colour of the paper for the whites and highlights in a subject. For example, in this painting there is only the slightest hint of colour on the building in the centre – much of the paper has been left white.

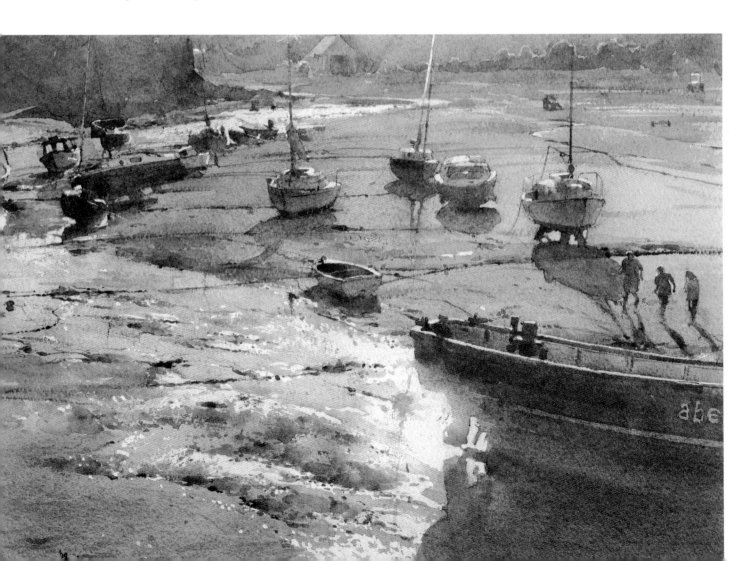

right *The Estuary, Padstow, Cornwall*
28.5 x 39cm (11¼ x 15¼in)

Estuary views can be very open and
horizontal, so try to find a view that includes
something that will counter this effect, such
as a well-placed boat.

below *The Old Swingbridge, Whitby*
28.5 x 39cm (11¼ x 15¼in)

Often, concentrating on an interesting section
of a harbour scene results in a more effective
painting than attempting a panoramic view.

In the opposite conditions, when the tide is coming in and the water is rising,
I start with a careful drawing to fix the position of the key elements of the
composition, and then I return the following day (allowing for the slightly later
time of the tide) to work on the painting stage. But always with harbour and
estuary subjects, speed is of the essence. You have to work confidently and with
all your technical expertise to capture the scene as quickly as possible.

Water

My advice here is to start with some very careful observation. Usually, water is moving, but if you squint at the subject you will notice how it divides into passages of dark reflections, mid tones, and little spatters of white in the lit areas. You have to decide how it is broken up into these basic elements and keep these in mind as you try to express the general effect with your brushwork, having initially masked out the glints and highlights.

When painting water the two most important things to remember are: firstly, that the whole of the water area is normally a tone darker than the sky; and secondly, that any reflections will be a half-tone darker than the object being reflected (the 'parent object'). Moreover, within the water area as a whole, the nearer section will always appear increasingly dark the nearer it gets to the viewer in the foreground, and this gives a sense of aerial perspective. I usually work a mid-tone (though variable) wash across the whole area. Then, with a series of quick horizontal strokes, mainly dry-brush, I build up the feel of the water, at the same time incorporating the dark reflections. If necessary, I soften some of these strokes with a brush and some clean water. Finally, I remove the masking fluid to reveal the highlights, which similarly may need subduing in places.

Reflections

The appearance and character of the surface of water is essentially determined by the colours and shapes reflected in it. Consequently, to help create a convincing sense of wetness, transparency and movement, it is important to look closely at the form and nature of the reflections. In fact, this process should be

Mudlarks on the Slipway, Staithes
39 x 57cm (15¼ x 22½in)

What I liked here was the challenge of suggesting the different reflections and textures.

The Reaper in Whitby, Yorkshire
39 x 28.5cm (15¼ x 11¼in)

Here, as well as suggesting a particular type of light and weather, the cloud forms play an important part in the structure and harmony of the composition.

Pages 104–105 ***Contre-Jour Light, Polperro Harbour, Cornwall***
57 x 77.5cm (22½ x 30½in)

This is the ultimate harbour scene and one that fully justifies a large-scale, considered painting in the studio. However, it is equally important to retain the wonderful freshness and quality of light experienced on site.

an integral part of the overall assessment of the water surface, as explained on page 102, and ideally the reflections should be treated as a key element within the initial variegated wash. This means having the necessary colours ready-mixed and working quickly and intensely.

In watercolour, reflections are unlikely to have any impact if they are superimposed as a sort of afterthought over a general wash. They work best when added wet-into-wet, so that they can be subdued and fused as necessary into the surrounding area. Like shadows, they must relate convincingly to the parent object, and similarly, the colour will be a greyer/bluer version of that object. Also like shadows, reflections can contribute in a very positive way to the composition, particularly as a means of linking different areas. See *The Reaper in Whitby* (left), for instance.

Skies

To a large extent the sky sets the mood for a landscape painting, and it will influence the general colour key and other aspects of a subject. Being a draughtsman, I like the sky to be a good shape within the overall composition, but it should not be too dominant. I often paint *contre-jour* (looking into the light), and I prefer skies in which the light source is behind clouds, so creating a soft halo effect. As in *The Reaper in Whitby*, I particularly enjoy subjects in which there are sky effects that can be used as an interesting, supporting element within the painting as a whole.

Painting Skies

I always start with the sky. In the same way that I paint water, the sky area is considered as part of the first sequence of washes, and I think it is essential to complete it in one go. With the drawing in place and the paper wetted all over, I consider the various cloud shapes and then re-wet the cloud edges to ensure that any subsequent washes of colour dry with a soft rather than a clearly defined outline.

Working quickly from the reservoirs of colour I have mixed, I begin with the blue area that surrounds the clouds and then immediately, perhaps with a mix of cobalt blue, raw sienna and a little

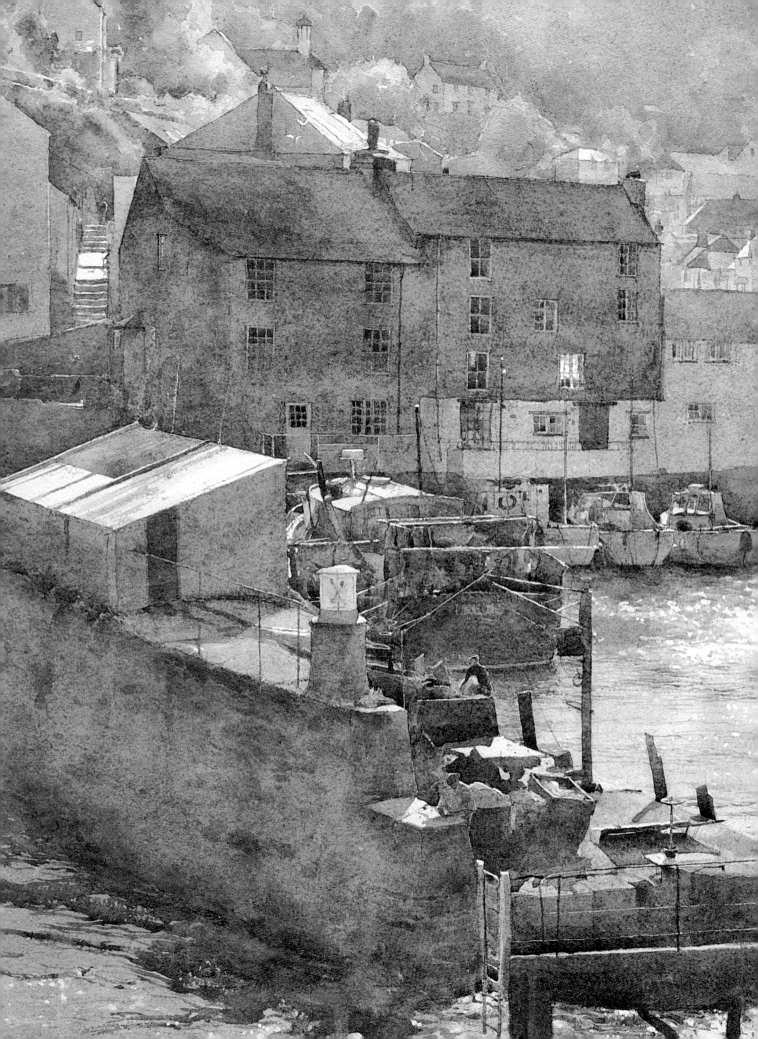

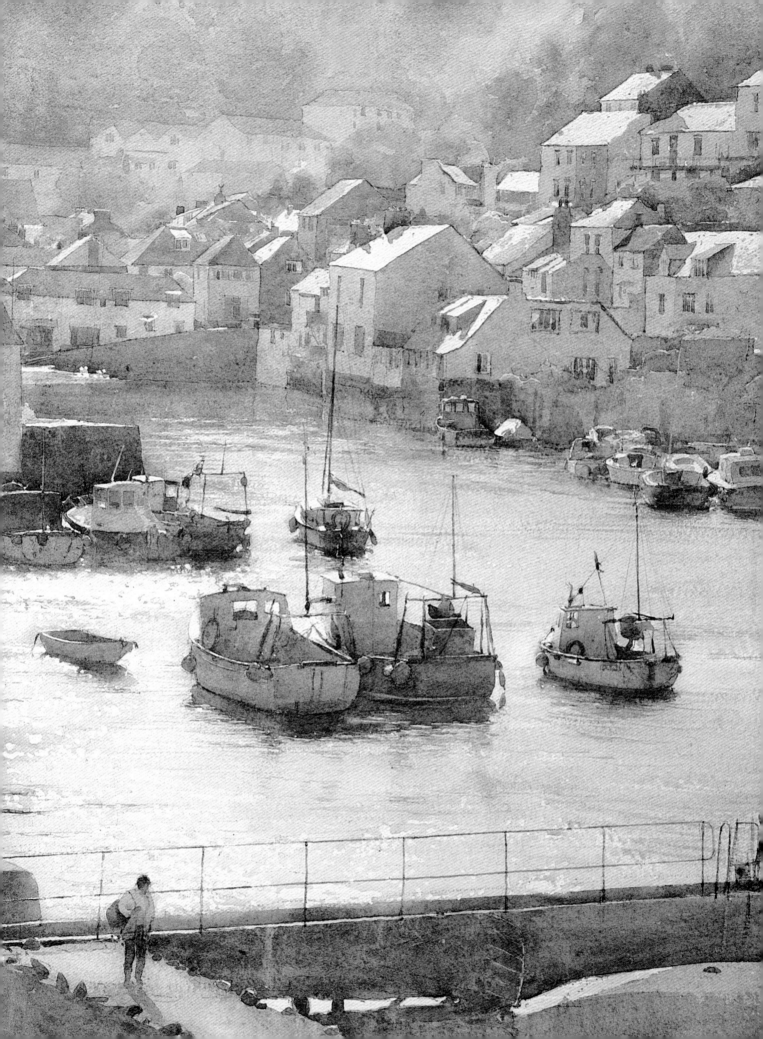

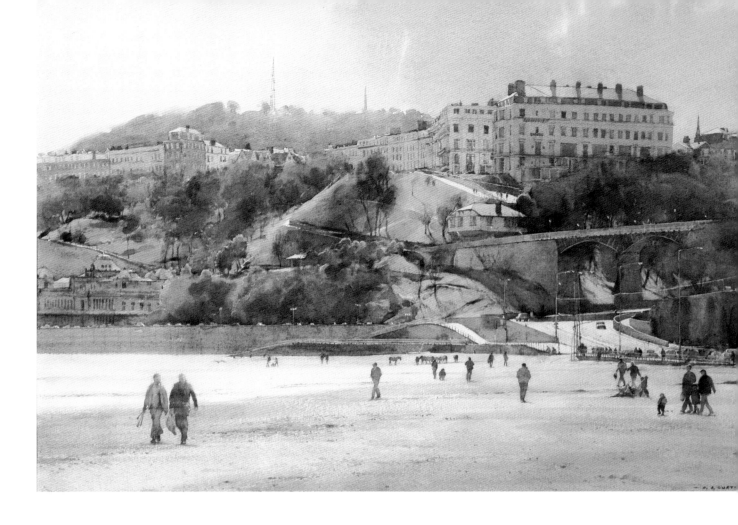

cobalt violet or light red, flood some colour into the cloud shapes. All the while I am careful to control the washes enough so that I never lose the wet, soft edge around the clouds. My aim is to suggest the light source and the broken, patterned effect of the clouds, but at the same time I want to keep the sky a very fluent part of the painting.

Always the sky will make some kind of statement, although in many of my paintings it isn't necessarily one of the strongest elements of the subject. I'm not

above *Sunshine and Shower Clouds,*
 Scarborough Harbour, Yorkshire

57 x 77.5cm (22½ x 30½in)

Making full use of the contrasts between the shadow forms and the glancing sunlight, my aim in this painting was to convey the particular sense of atmosphere and light that occurs after it has been raining.

left *The Road to Newington Village*
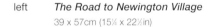
39 x 57cm (15¼ x 22½in)

This sky suited the traditional wet-into-wet approach to create soft-edged cloud forms.

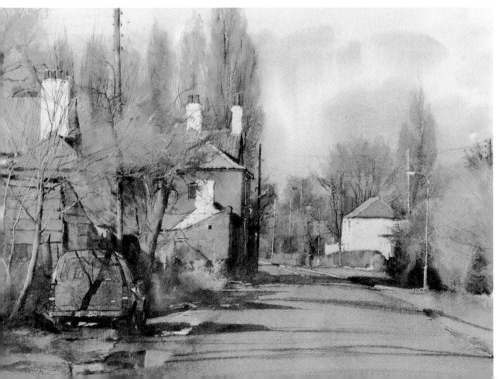

one of those painters whose main concern is 'the weather', and in fact in some paintings I do not include a sky at all – see *Contre-Jour Light, Polperro Harbour*, for example (pages 104–105). But even here, although the sky is not actually shown, its mood and character are implied by the way that light and colour are reflected in the water. On other occasions I work from a combination of the sky as I see it, and my knowledge and experience of more interesting yet equally suitable skies. This was so in *Ben Eighe Above Torridon* (page 110). The drama of the threatening rain clouds across the hillside was something that I had witnessed only the day before.

Sacré-Coeur Skyline, Montmartre, Paris
39 x 28.5cm (15¼ x 11¼in)

A perfect scene to paint, with approaching cloud on an otherwise faultless, sunlit day.

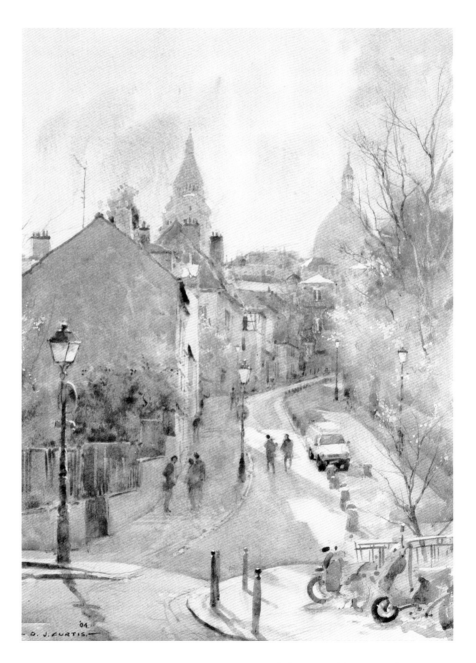

Landscapes

With landscapes, I am looking for a combination of a striking composition and all the other elements that make up the 'wow' factor in a subject. Preferably, I want a scene that is dynamic and dramatic from the drawing point of view. However, although I often find subjects that fulfil all of these objectives, sometimes I am prevented from actually working on the spot (or at least from the ideal viewpoint) because of various practical difficulties.

For example, it may be dangerous, or simply too busy with people or traffic, to work on site. In those circumstances I have no qualms about taking photographs as a source of reference, and photographs can also be useful when there are groups of people or other moving or transient subjects and effects that one would like to paint. But I would recommend using photographs only in this sort of 'emergency' situation; avoid relying on them. Treat them as an *aide-mémoire*, rather than something to copy.

I enjoy painting on my own, although I also frequently paint with other artists at different locations, which is something I would recommend. It is a sad reflection of the modern world to say so, but it can be unwise to paint on your own in a lonely place. On the other hand, where there are people you are likely

Crisp Spring Day, Dale Head, Derbyshire
28.5 x 39cm (11¼ x 15¼in)

A typical landscape view, but one in which the light enhances the simple shapes to create some strength of form in what otherwise might have been a very even-toned subject.

to attract attention from inquisitive passers-by. In both situations the burden is eased by painting with a companion or two. A good trick to help you avoid being drawn into conversation by a passer-by while you are trying to concentrate on your painting is to hold a paintbrush crossways in your mouth!

At the moment I am very interested in views that combine buildings and landscape, as in *Bryanston Square* (page 111). I like the contrast of different man-made and natural surfaces and textures that these subjects offer, such as foliage, masonry and glass. I can also delight in the drawing involved in these more complex scenes which often, additionally, include figures. The opportunities for finding interesting landscape subjects are virtually limitless, so there is plenty to keep me motivated and challenged.

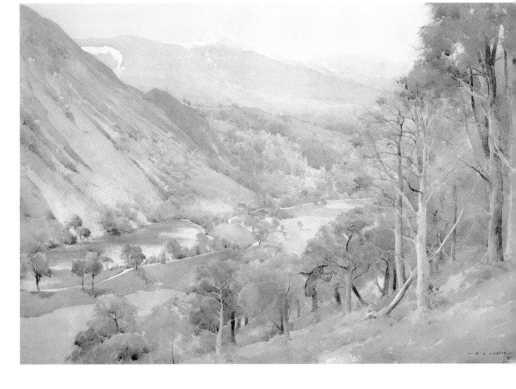

Ancient Pine Forest, Aviemore, Scotland
57 x 77.5cm (22½ x 30½in)

As I found for this commissioned painting, it is not impossible to work *en plein air* on a large scale, but you do have to be fit, well-organized and confident!

A Sense of Scale

When painting any landscape, and especially when considering complex undulating or panoramic views, one of the most difficult qualities to achieve is a convincing sense of space and depth. In reality, a view such as the one shown in *Ancient Pine Forest, Aviemore* (above) covers a tremendous area and distance from the immediate foreground to the far mountains. So, how can artists successfully convey a feeling of immense distance, given the constraints of a small, two-dimensional sheet of paper?

I believe that success with this particular aspect of landscape painting (and it applies equally, of course, to painting other subjects) relies mainly on understanding how the scale, tonal values, colour, and degree of detail are

influenced by their relative distance from you, as well as the effects of light and atmosphere. An important point to bear in mind, for example, is that the intensity of colour is successively reduced the further you look into the distance. Far-off colours appear to acquire a bleached quality; they are weaker in tone and colour intensity.

A common mistake is to make distant greens too strong – a consequence, perhaps, of the artist painting what he or she knows about the colour of the distant objects, rather than how they actually appear from the painting vantage point. Strong colours attract the eye, and so they jump forward. Therefore, in general, the most powerful colours will be in the foreground or middle distance. You will also notice in *Ancient Pine Forest, Aviemore* (page 109), that the distant mountains have a much cooler, blue/purple hue. Background hills and other landscape forms often look blue rather than green, due to the influence of atmospheric haze, which softens and distorts the colour. This effect, known as aerial perspective, is something that artists are often tempted to exaggerate to enhance the feeling of depth in a painting. However, it is best to rely principally on what is observed, I think, rather than contrive to produce dramatic effects by the application of particular theories.

As for detail, the nearest objects will naturally be the ones that are seen, and therefore interpreted, in the sharpest focus. Usually, the drawing in the foreground will be more considered. In the distance, shapes such as windows and doorways might be defined in part, but with other areas 'lost' against the

Ben Eighe Above Torridon, Scotland
39 x 57cm (15¼ x 22½in)

This painting was inspired by the sense of awe and drama that I found at Ben Eighe, which I had climbed the previous day.

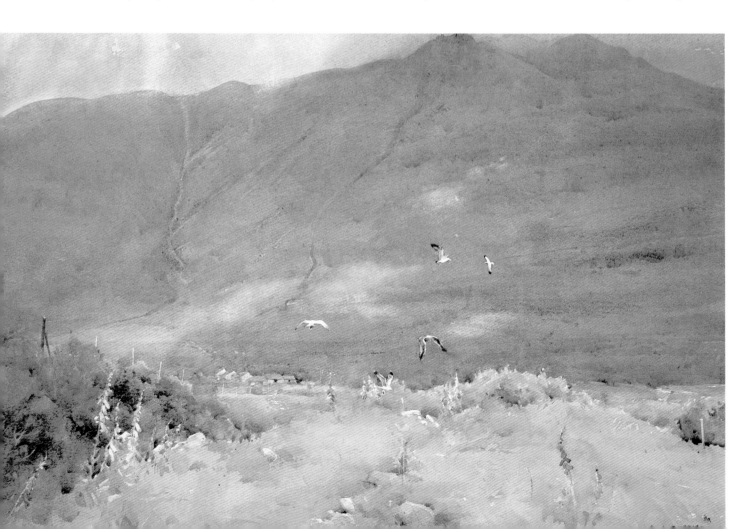

background. Suggesting space and depth relies on what I would call a downplaying exercise – making the detail less obvious and the tone and colour weaker as you deal with successively more distant parts of the view. This is a very delicate process that demands concentration, because it only needs the tiniest overplay of an otherwise well-painted distance to spoil it. A distant object that is a touch too dark or too detailed is enough to destroy the whole feeling of intervening space.

Foreground Interest

In many landscape subjects the foreground is a relatively uneventful area and, as in *Ben Eighe Above Torridon* (left), it may consist only of an expanse of grass. In fact, for this painting (which I undertook as a commission), my first thoughts were that the foreground was insufficiently interesting, and I thus had my doubts about pursuing the idea further. But, by moving my viewpoint slightly and using a little artistic licence, I found I could incorporate a small tussocky knoll, with some foxgloves on the left. This was just enough to add interest and lead the eye into the subject.

At the other extreme, a very complex foreground can be a distraction. Ideally, the aim of the foreground is to provide a sort of 'cushion' area, beyond which the main action of the painting takes place. As I have said, it should be a space that attracts the viewer into the picture and instigates a certain pattern of movement of the eye around the painting. In this respect it can play a key part in the composition. However, as with any aspect of watercolour painting, it

Pages 112–113 *Old Willows on the Idle, Misson, Yorkshire*
39 x 57cm (15¼ x 22½in)

In this subject, dappled shadows added interest to what could have been quite an empty foreground area.

Bryanston Square, London
39 x 57cm (15¼ x 22½in)

Foreground shadows can be a very useful linking device, especially in compositions that mainly involve trees or other vertical forms.

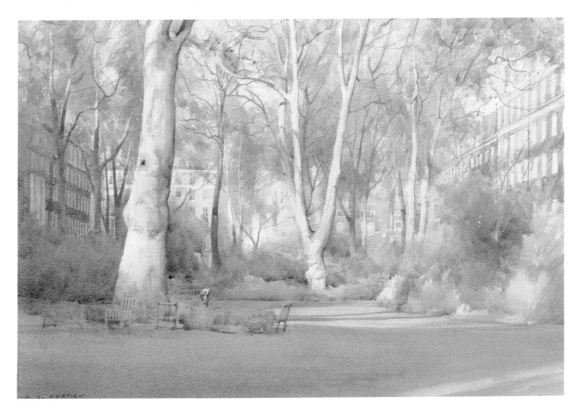

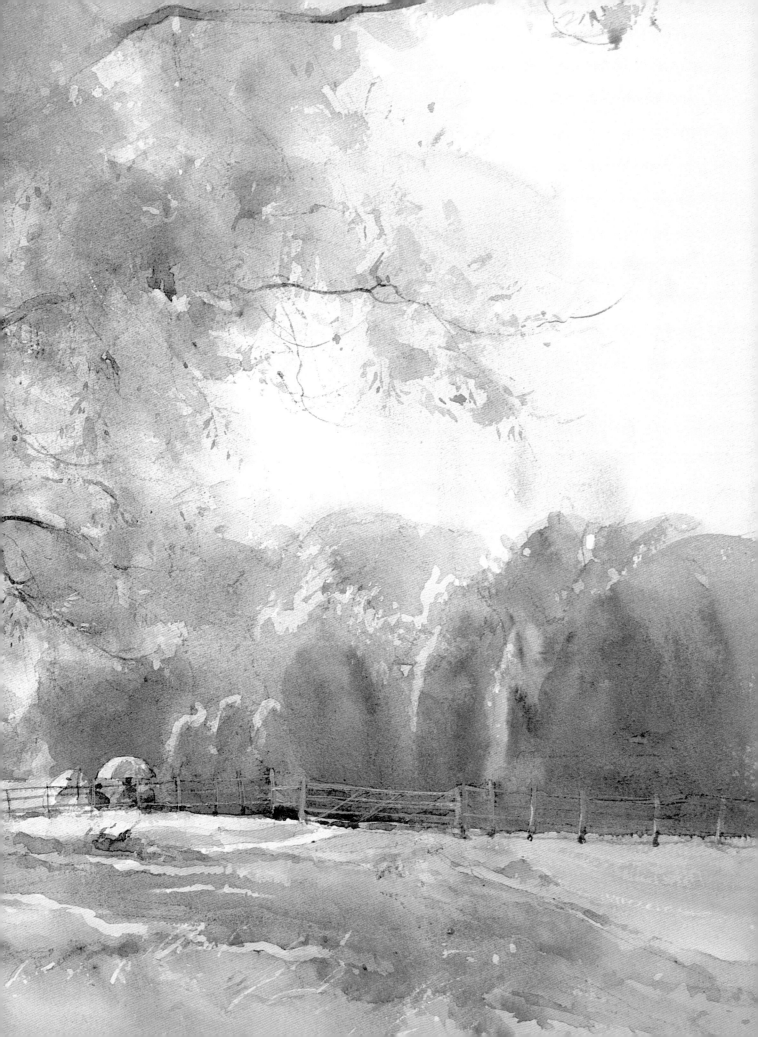

must not look contrived. Don't be afraid to use a bit of invention, but ensure that anything added or subtracted is compatible with what is actually observed.

Sometimes just a variation of colour, a different type of brushwork, or a cast shadow can be enough to break up the foreground area, complement the design, and create the necessary degree of interest. In *Edge of the Lake, Sandbeck* (below), for example, notice how I have used a wash of broken colour, while in *Bryanston Square* (page 111) and *Old Willows on the Idle, Misson* (pages 112–113), shadows are important in enhancing the foreground area.

Trees and Foliage

Trees are one of the principal features of most landscapes and they are always interesting, challenging subjects to paint. I look for trees that have a sense of majesty and offer some strong, well-balanced shapes to use in the composition, like the magnificent elm in *Edge of the Lake, Sandbeck* (below). There are two main points to be aware of when painting trees: creating a shape and outline that is not too solid and defined, but with the suggestion of form and foliage; and, in a similarly sensitive way, capturing the feeling of light wherever it shines through the foliage.

With tree shapes I usually start with some drawing, but keeping this faint, loose and lost-and-found; I do not want an outline as such. Then I apply some masking fluid to those areas where the sky will show through, and to any specific branch shapes or highlights that I want to preserve. From the washes of

Edge of the Lake, Sandbeck, Yorkshire
39 x 57cm (15¼ x 22½in)

I like to consider the tree forms mostly within the initial wash, so ensuring that the outlines are not too strongly defined.

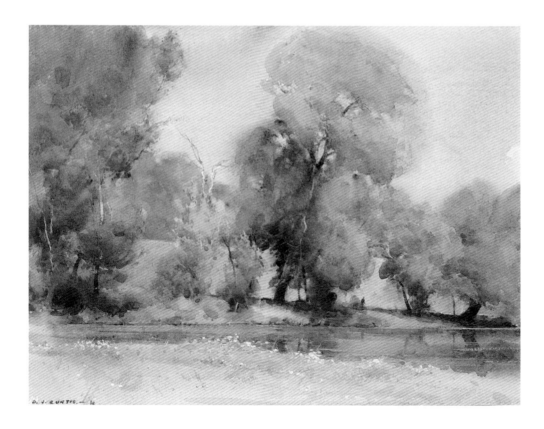

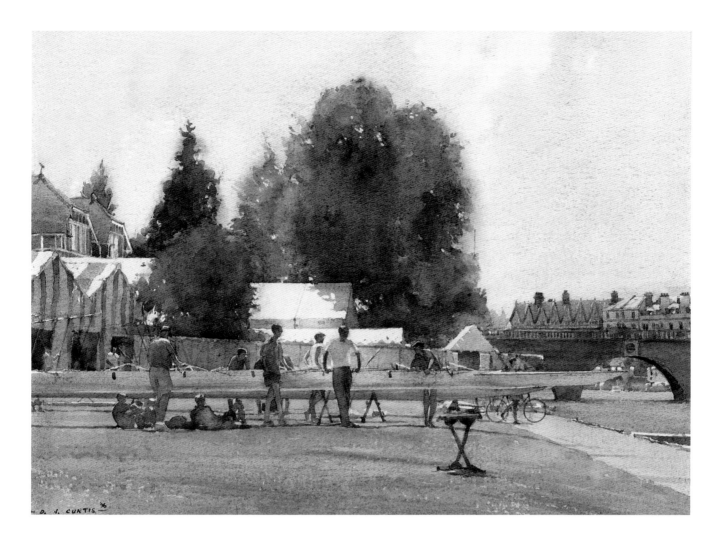

The Boat Tents, Henley Regatta
28.5 x 39cm (11¼ x 15¼in)

The attraction here was the extreme quality of light on the tents, which made a dramatic contrast with the surrounding dark trees.

colour that I have prepared I paint the sky area (around but not over the tree shape) and then, immediately, the mass of foliage, so that the edge drifts slightly into the sky colour and is consequently softened.

Essentially the foliage part of the tree is one continuous, variegated wet-on-dry wash, which changes to match the general lights, darks and variations of colour that are observed. With the masking fluid protecting the gaps where the sky shows through, I can confidently work with broader washes without fear of losing the light areas. When these initial washes are dry I may strengthen the colour here and there, and then I remove the masking fluid and deal with the patches of sky, highlights and important details. This approach, I find, will give tree shapes that are not too stark and have the necessary sensitivity in their structure and form.

Obviously, the other challenge with foliage is handling the variety of greens so that they are not too incisive. When I come across really strong greens I tend to knock them right back, making them rather more subtle than they actually are. This makes the painting work far better in the traditional watercolour technique that I so passionately believe in. Most of my greens are made with French ultramarine and raw sienna, and sometimes I enrich this mix with a little viridian or lemon yellow. If I want a slightly higher-pitched green, I use raw sienna and viridian.

Buildings and Interiors

I have always loved painting interiors, and on every painting trip I will seek out this type of subject in preference to landscapes. I particularly like the busy, often dramatically lit interiors of workshops, forges, barns and boatyards. Containing an array of different tools and other objects, these interiors offer fabulous shapes to draw and, with their powerful sense of skill and purpose, an atmosphere that is second to none.

My interest in interiors started in my childhood, when I was much inspired by the work of Adrian Hill. I had a number of his books and I wanted to emulate his obvious delight in barn and forge interiors, and his immense sensitivity and skill in drawing them. Later, I used to go out with various art groups to draw and paint these subjects, which at that time were much more plentiful than they are now. So, when I do find the sort of interior that is shown in *Old Mill Workings, Stone Mill* (below), I make the most of it. What I liked here, apart from the jumble of objects and the potential they gave for drawing and composition, was the wonderful, directional light effect, which created lots of lost-and-found edges. This kind of subject never ceases to excite me!

Old Mill Workings, Stone Mill
57 x 77.5cm (22½ x 30½in)

Although this is a large studio painting, to help me fully convey the grandeur of the scene I did all the preliminary drawing on site.

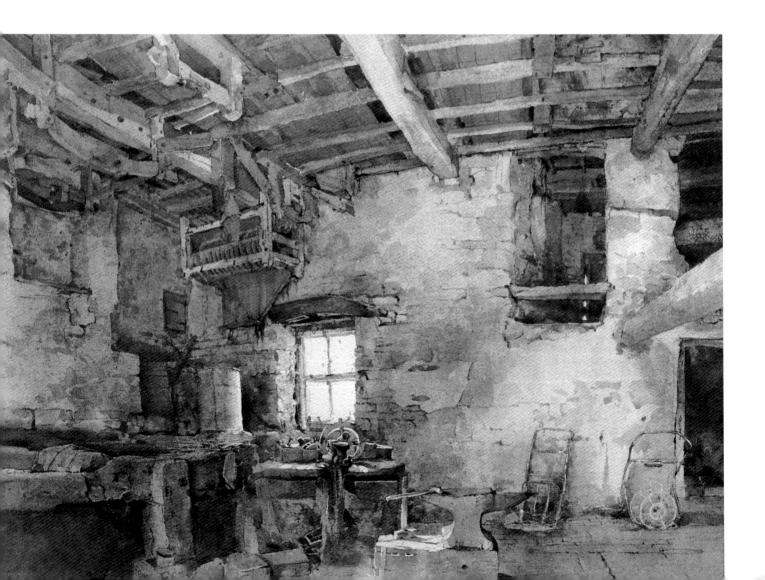

Simplification

Inevitably a complex interior or group of buildings cannot be expressed in every detail in a painting, nor would it be a good idea to do so. Paintings that are very 'busy' are usually far less effective than those in which the main elements are suggested, but something is left to the viewer's imagination. It is therefore a matter of deciding which things are important – in contributing to the idea and impact you want to convey – and which things can be drastically simplified or even left out altogether. Technique and other practical considerations also have an influence. I prefer to work with broad, variegated washes whenever possible, and consequently I aim for an impression, based on my personal response and individual technique, rather than striving for a perfectly representational result.

In many interiors, such as those demonstrated in *First Floor, Barn Interior* (page 118) and *In for Refit, Thorne Boatyard* (below), there will be some areas, most likely in the foreground, where the objects are clearly identifiable, and others where there is a complicated mass of different shapes and it is impossible to determine exactly what is going on. The way that I deal with intricate areas is to look at them through half-closed eyes, which helps me focus on the main shapes and the lights and darks. Then I paint the area accordingly, varying the wash to pick out a little more detail here and there, and thus hint at more specific objects. Subsequently I may add a few intense darks, so that the shapes 'read' more clearly. But essentially the aim is to describe what is there without saying too much.

In for Refit, Thorne Boatyard

39 x 57cm (15¼ x 22½in)

It is essential to adopt a disciplined and selective approach in order to make sense of the detail and complexity found in many interior subjects.

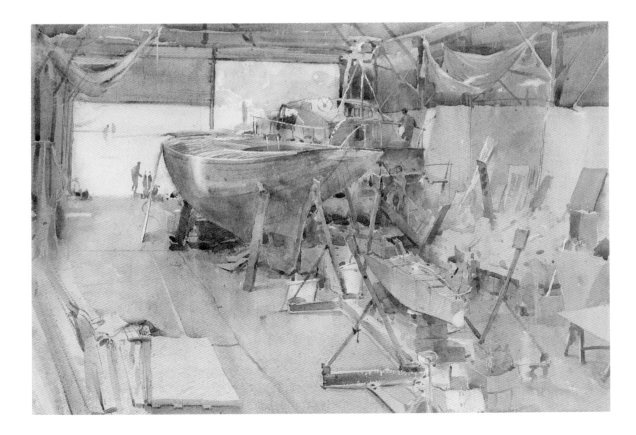

above *First Floor, Barn Interior*
39 x 57cm (15¼ x 22½in)

This was an inspirational place, but rather a
jumble. So, I improved the composition by
actually moving some of the objects and
clearing a pathway towards the door.

left *Old Barn Interior, Stone Mill*
39 x 57cm (15¼ x 22½in)

This simple, delightful barn interior was a
subject that I came across at the end of a
day's painting, and which I found too good
to resist.

I also adopt this approach for a panoramic city view, such as *Paris Cityscape from Montmartre* (pages 120–121). This painting looks really complex, with a vast expanse of rooftops and buildings, but actually it was quite straightforward. I used masking fluid to reserve the highlights on the roofs and then, after completing the sky area, most of the buildings were suggested with a graduated wash. In the middle distance I added a further, subtle wash and, of course, there is some fairly radical drawing in the foreground.

Perspective

An appreciation of perspective, and the ability to apply the principles of perspective where appropriate, are essential skills for every artist. Naturally, perspective is a particularly important consideration when painting interiors and buildings, as these subjects inevitably involve specific angles and changes of scale that must be judged and drawn correctly if the work is to look convincing.

The method I use for assessing and drawing the angles of buildings is very simple yet effective. I hold my pencil at arm's length, in line with the angle of the building, keeping it there for a few seconds to help fix the angle in my mind. Then, I slowly move the pencil down onto the watercolour paper, taking care to keep it at the correct angle, and, with a flowing movement of the hand, I draw the line. I re-check the angle of the line and alter it if necessary. To do this, the paper must be square-on to be subject, and I ensure that the pencil lines are

Pages 120–121 *Paris Cityscape from Montmartre*
28.5 x 39cm (11¼ x 15¼in)

Panoramic views are challenging but not impossible if you focus on the essentials and make full use of the changes of light and tone to suggest distance.

below *Carlton House Terrace, London*
39 x 57cm (15¼ x 22½in)

A perfect example of a perspective view. Note the way that I have used the tree forms on the left to counter the strong directional flow of the perspective lines and to aid the composition.

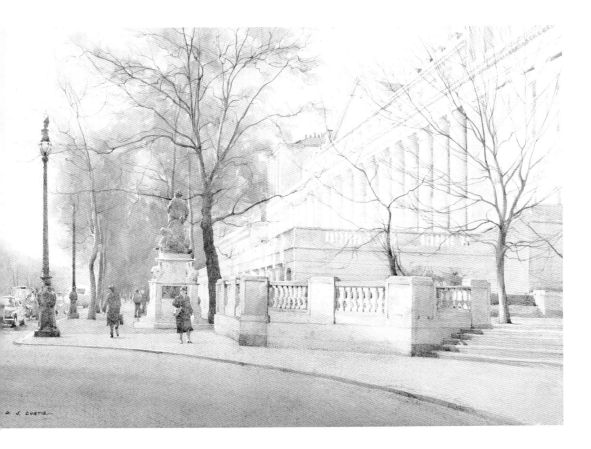

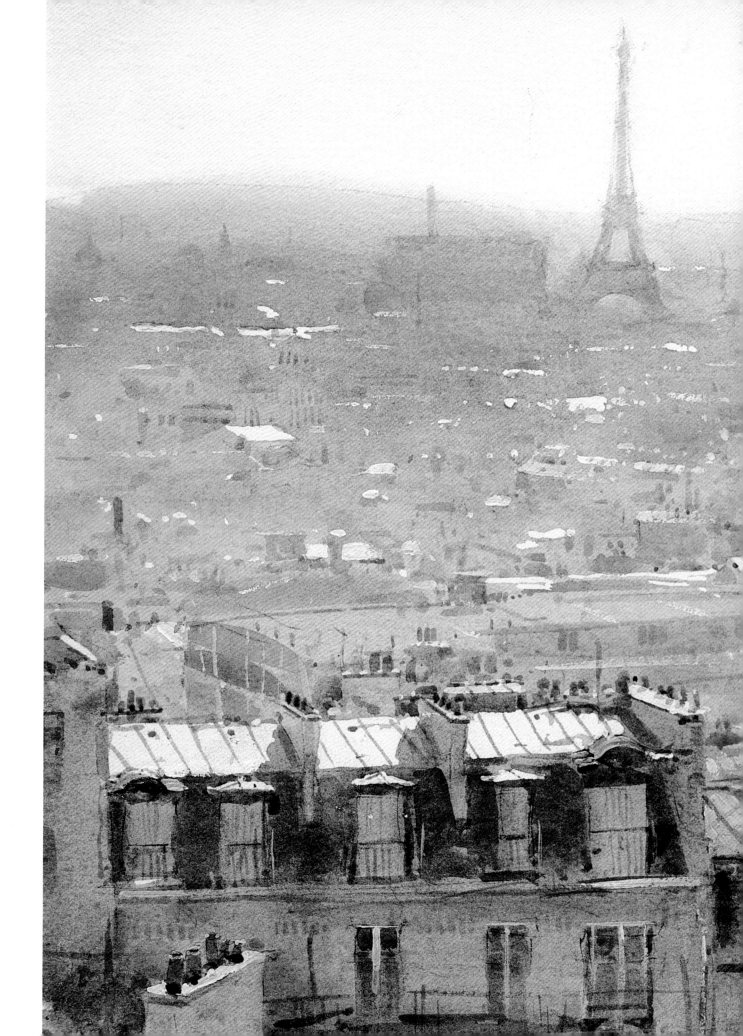

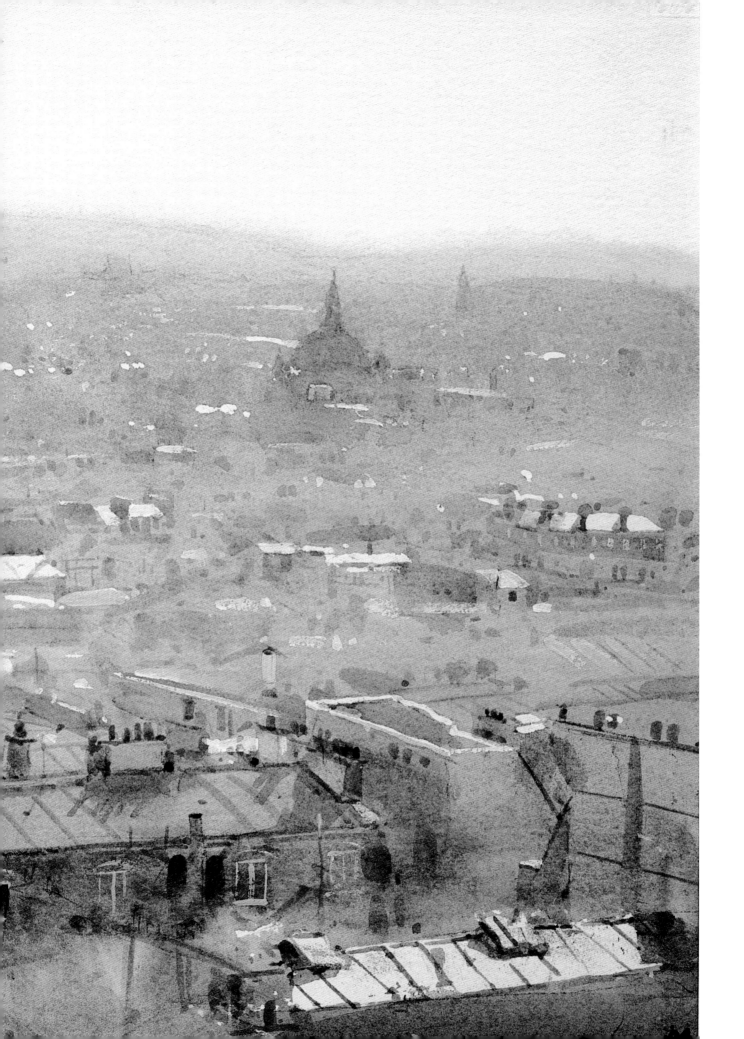

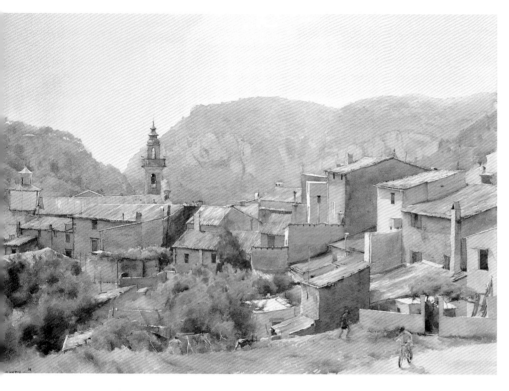

The Monastery, Valledomosa, Mallorca
39 x 57cm (15¼ x 22½in)

This made a lovely composition, with the tower as a focal point positioned on the Golden Section.

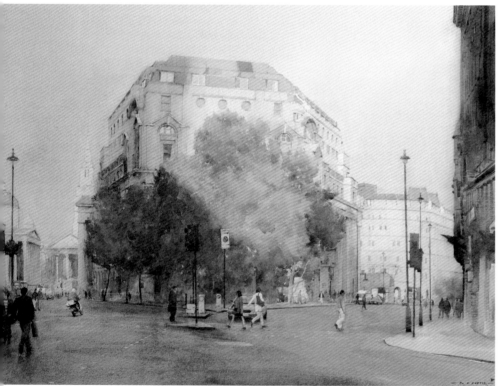

Towards St Martin's, London
39 x 57cm (15¼ x 22¼in)

I liked the huge central mass of buildings and the strong sense of perspective in this subject, which reminded me of similar views I had seen on a recent trip to New York.

lightly drawn (with a 2B or 3B pencil) so that I can easily rub them out later. This was the method that I used for drawing the façade shown in *Carlton House Terrace, London* (page 119).

Once the key lines of perspective are in place, other features, such as doorways and windows, can be judged in relation to them. For a more complex view, like the one shown in *The Monastery, Valledomosa, Mallorca* (above),

I start with the focal point – in this case the tower on the left – using this as a reference for scale as I develop the drawing around it. First I concentrate on the large, basic shapes, which are essentially squares, rectangles and so on, and then, as necessary, I resolve them further.

As I have mentioned, I believe that making the initial drawing is one of the most crucial stages of a watercolour painting. However inspired you are by a subject, creating a sound structure for the painting (which of course includes checking all the angles and the relative proportions of the different objects) is invariably a vital first step. Lax work at this stage will seriously compromise the chances of success.

Textures

I greatly enjoy observing the variety of surface textures that can be found in buildings and interiors, and it is very rewarding to interpret these with traditional watercolour washes. A wall of a building might include areas of flaking plaster, for instance, or perhaps panelled wood or lichen-covered stonework. Similarly, there are many different kinds of roofs – slate, tile, thatch, rusty corrugated iron, and so on. For each of these surfaces it is not just a matter of mixing the right colour, but of applying the paint in such a way that it suggests a particular texture.

Textures add interest to a painting. The result can look rather dull and uneventful if every area is simply dealt with in terms of flat washes of colour. Consequently, I adapt my technique to help me describe the different surface textures. For example, in *Beynac, Dordogne* (page 124), each part of the

Old Cruck Cottage, Harworth, Nottinghamshire
39 x 57cm (15¼ x 22½in)

I painted this as a celebration of simple, artisan architecture. Unfortunately this building has since been demolished to make way for a roundabout.

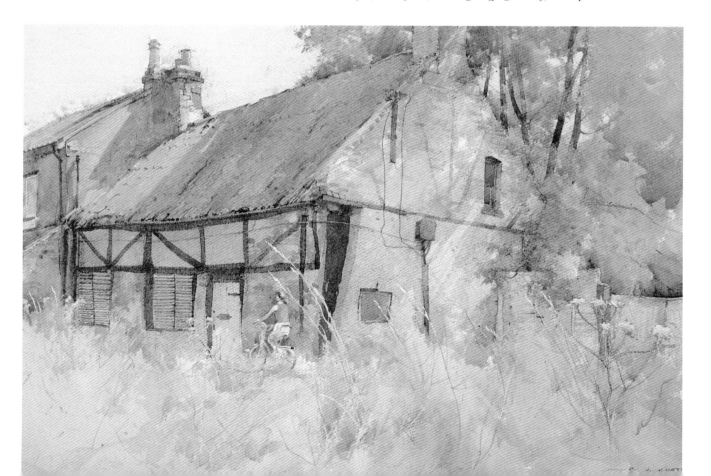

Beynac, Dordogne, France
28.5 x 39cm (11¼ x 15¼in)

This painting was originally much larger, but it somehow lacked the impact I had hoped for, so I trimmed it to a smaller size, to better effect.

painting – sky, buildings, foliage and foreground – involved a different way of handling the watercolour washes.

The weight and surface quality of the paper, as well as the technique chosen (wet-into-wet, wet-on-dry, graduated wash, variegated wash, dry-brush, masking out and so on) are the two key factors that will determine the texture effect. Other techniques, such as wax-resist, stippling or combining watercolour with other media, will also produce interesting textures, but they are not for me, since they reduce the transparency of watercolour, which I value.

Figures

Figures add life and movement to a subject, they give a sense of scale, and they enhance the impact of the composition. For me, the attraction of many subjects is the particular grouping and action of the figures. In *The Thames at Henley, Regatta Week* (page 126), for instance, note the way that the figures provide a strong, compositional link between the foreground and the distance and how they create a feeling that something is happening.

Care must be taken not to treat the figures as a separate entity from the rest of the painting. The greatest problems are likely to arise if you work from

photographs and attempt to add the figures at a late stage, perhaps trying to superimpose them on a previously painted area. Alternatively, you may decide to leave a space for the figures and come back to them when everything else is finished. In both instances there is a danger that the figures will look wooden and out of context. The best approach is to consider the figures right from the start and work them in as you develop the rest of the painting. Then, they will be in harmony with their surroundings, and thus far more convincing.

Essential Features

There is no doubt that figures are one of the most difficult subjects to sketch and paint. It requires a lot of confidence and skill to draw figures well and place them in exactly the right position in a composition, especially if they have to be drawn on a large scale and are the main feature of the work. However, the necessary confidence and experience can be developed over a period of time if you are prepared to do plenty of observation and practice.

Essentially this means carrying a sketchbook with you wherever you go and filling it with small studies in which you try to capture different poses, activities and types of figure. Try jotting down one or two little sketches when you are in a café, for example, a shopping mall, or waiting at a station or airport. Regular life-drawing classes are also extremely helpful. Many professional artists make a point of doing some life drawing each week, as this helps keep their observation and drawing skills in good shape.

In your sketchbook drawings, concentrate on the poise and body language of the figure. You will need to draw quickly, aiming to suggest the character of the figure, the sense of movement and so on, in a few sensitive lines. Many types of media are suitable, but I would suggest pencil or fibre pen to start with. Aim for spontaneity and liveliness in the drawings – after all, they are of living, moving subjects! It doesn't matter if they are unsuccessful – you can try again, or move on to another figure. But in time you should build up quite a resource of figure studies that are useful for inclusion in your paintings.

Groups and Crowds

Many of my figure paintings are of scenes at Henley Regatta (a week of rowing competition held on the Thames in Oxfordshire each June), which I visit every year, and these are either small watercolours painted on site or much more resolved studio paintings based on various types of reference material. Whatever the approach, I ensure that the figures are planned in relation to their surroundings and developed at the same pace as the rest of the painting.

Reflections, Henley (page 127) and *The Thames at Henley, Regatta Week* (page 126) are examples of figure compositions that are painted mainly on site. For these, I usually work on ¼ Imperial (28.5 x 39cm/11¼ x 15¼in) sheets of paper, often from an Arches watercolour block. I generally choose a slightly more limited palette, and I start by drawing the figures and masking out areas such as the white T-shirts. The figure drawings obviously have to be made very quickly, based on a combination of what I can observe, memory and experience. Next, I block in most of the colour washes, but I leave the final definition until later, in

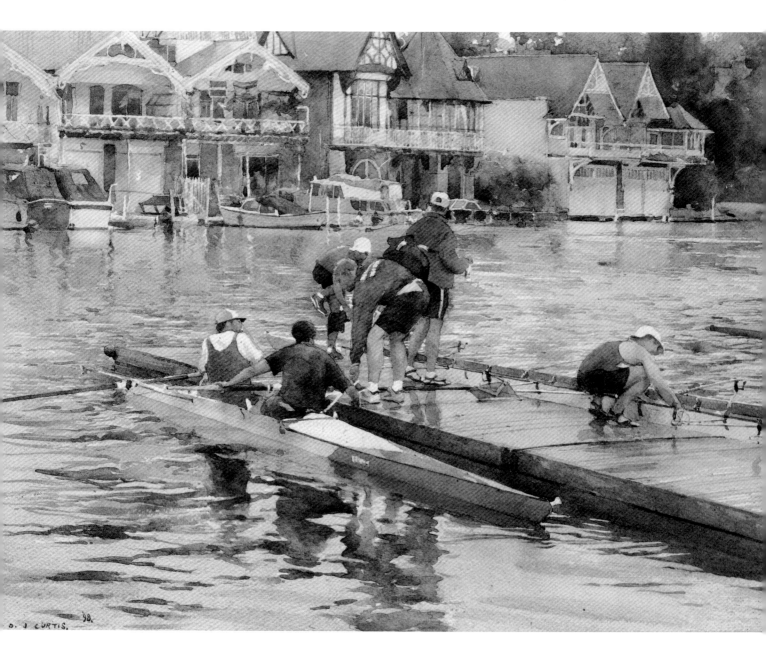

the studio, where I can refer to other sketches and photographs for reference if necessary. These paintings have a more natural, spontaneous feel than those made entirely in the studio, but I have to accept that they will not all be successful.

For the larger, studio paintings, such as *Rainy Day, Henley* (right), I work from the watercolours, oil sketches and drawings that I made on site, plus any photographs that I have taken. The advantage of these paintings is that there is far more time to plan and consider things, so I can work on a much larger scale and with greater control and detail. I try to create the same feeling of action and atmosphere that I experienced on site, but inevitably such paintings look more 'staged', I think.

The Thames at Henley, Regatta Week
28.5 x 39cm (11¼ x 15⅜in)

In this scene, the background creates just the right amount of interest and balance in relation to the lively group of figures.

right *Reflections, Henley*
28.5 x 39cm (11¼ x 15¼in)

A group of figures like this makes a wonderful
focal point for a painting.

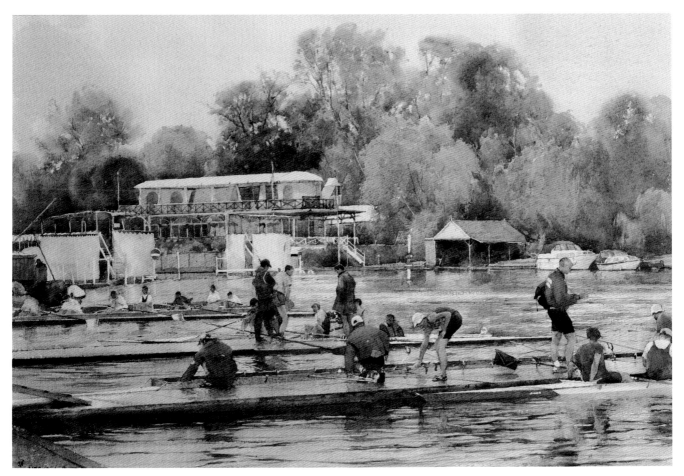

Rainy Day, Henley
39 x 57cm (15¼ x 22½in)

The thoughtful grouping of the figures against the strong, horizontal
shapes behind made this a very satisfying composition.

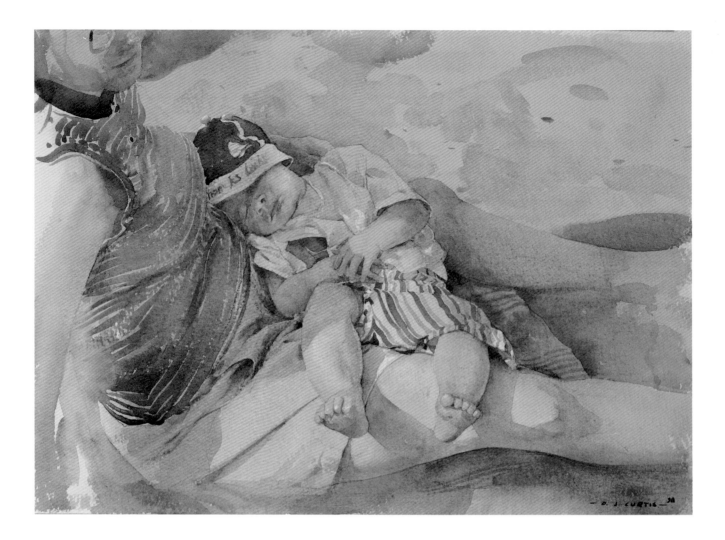

Portrait Studies

With portraits, as with any subject matter, the more you know and understand what you have chosen to paint, the more successful the final result is likely to be. The two portrait studies I have included here are good examples of this. *Beach Study with Mother and Child* (above) is a study of my young son – in fact made with the help of photographs, but of course relying mainly on my intimate knowledge of him – while *Portrait of Lily* (right) is a painting of a former neighbour of mine whom I knew extremely well.

A knowledge of the sitter helps you express something of their character in the painting. For instance, I knew that Lily had spent more than forty years working in a cotton mill, and I could see that her hard-working life was reflected in the character of her hands and face, and this was a quality that I wanted to emphasize. In this portrait the form and features of the face were suggested right from the beginning, in the subtle variations of warm and cool tones of the initial wash. There is no magic formula for painting flesh tones. Each portrait is different in that the delicate colour mixes (which may include raw sienna, cobalt blue and permanent rose) are equally influenced by reflected colour and the quality of light in addition to the distinctive skin colour and features of the particular sitter.

Beach Study with Mother and Child
19.5 x 28.5cm (7¾ x 11¼in)

Here, the aim was to capture the relaxed charm of a sleeping child.

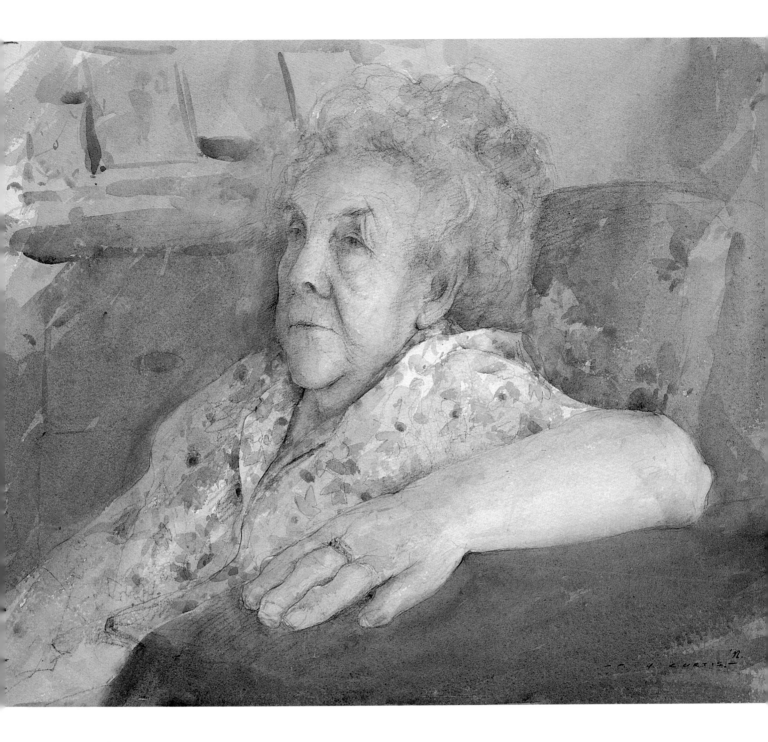

Portrait of Lily
39 x 57cm (15¼ x 22½in)

I couldn't resist the opportunity to paint this
wonderful character, who insisted on changing
into her 'best frock' for the occasion!

5 Working Methods

To meet the challenges of different subjects and conditions it is a tremendous advantage if you can rely on more than one type of working method. For example, when outdoors you may need to paint very quickly, with broad, confident washes, in order to capture the quality of light and other transient effects that interest you. On the other hand, in the studio there is time for a more considered, controlled way of working. Naturally, every subject requires a slightly different painting method, although in my experience the general approach will fall into one of three main categories: *plein-air* painting (on site, in front of the subject); a combination of on-site and studio work (the 'Middle Way'); or studio painting (the 'Considered Approach').

For me, *plein-air* painting means a fast, loose approach, working on small sheets of paper (usually ¼ Imperial: 28.5 x 39cm/11¼ x 15¼in) directly from the subject. The aim is to make useful reference studies, especially of fleeting or moving subjects, or paint small-scale, uncomplicated landscape scenes. I wouldn't expect to produce many finished, saleable paintings like this, although some are very successful, perhaps largely due to the vigour and spontaneity with which they were painted. Some *plein-air* paintings are effectively studies – maybe of trees, cloud formations, boats and so on – that can be incorporated into a more resolved watercolour or oil painting later on.

With *plein-air* work I normally start with a limited amount of drawing, then I use mainly graduated washes applied to dry paper, working with perhaps as few as three or four colours. The idea is to capture the scene or effect in a direct, non-fussy way. Once something has been stated it is left alone – otherwise the sense of immediacy and transparency is lost.

For a more resolved painting, still with the emphasis on achieving that feeling of spontaneity, I use what I call the 'Middle Way'. Here, the majority of the work is made on site, but the final details and adjustments are sometimes left for consideration in the studio. Assuming the light and other conditions are favourable, there will be time to think about the composition, make a sound drawing, and develop the essential colour washes. The most important aspects of the painting to establish on site are those that are transient – the particular quality of light and shadows, the position of boats and tides, and so on. Things that do not change, such as buildings, can be added at a later stage. Occasionally, if I need more time, I return to the subject the following day. Otherwise I complete the painting in the studio.

My third general working method, the 'Considered Approach', is studio-based, and for this I use location sketches and photographs as the reference material. The advantages here are that I can work on a large scale, often on a full Imperial sheet of paper (57 x 77.5 cm/22½ x 30½ in), and with a greater emphasis on drawing and detail. But, as in any studio painting, I am careful not to overwork the idea and thus lose the freshness and transparency of the colours.

Steam Rising, Grosmont Station, Yorkshire
39 x 28.5cm (15¼ x 11¼in)

Plein-Air Painting

View Above Dale House is typical of the type of subject matter that I like to tackle in a *plein-air* manner. What attracted me to this scene was the extraordinary quality of the light, which created interesting, lengthening shadows. I worked on this from about 2 pm until 3.30 pm and, since it was in

STAGE 1

View Above Dale House

Pencil drawing on stretched watercolour paper, with the relevant areas blocked out with masking fluid.

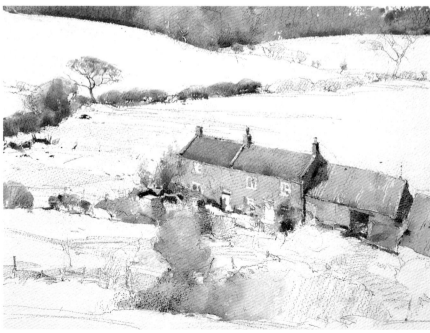

STAGE 2

View Above Dale House

The first washes were applied to the distant tree area and the cottages, mostly with mixes of raw sienna, burnt sienna and French ultramarine.

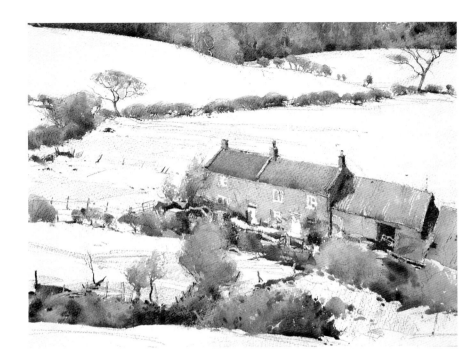

STAGE 3

View Above Dale House

At this stage I was considering the foreground, and how it will link with the rest of the painting.

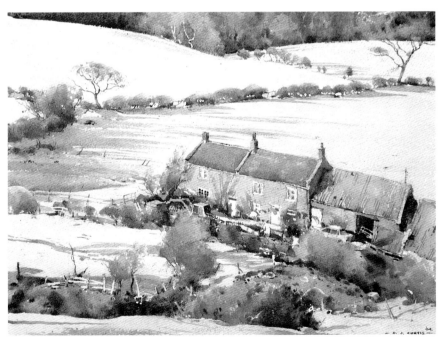

STAGE 4

View Above Dale House

Here I added the shadows with a mix of cobalt blue and cobalt violet.

winter, the light was changing rapidly and I had to work very intensely. The scene was painted largely on site, from a vantage point at the side of the road, looking down over the valley.

I began with a quick drawing (stage 1) to set the position of the cottages and briefly indicate the direction of the hedgerows and the outline of the fields at

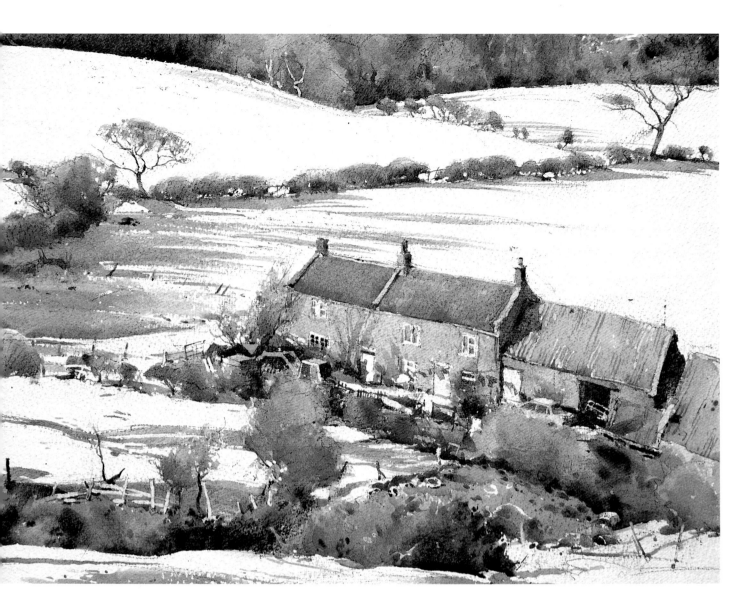

the top. The placing of the cottages was crucial to the success of the overall design – in a line finishing just beyond the centre, towards the Golden Section proportion, seemed about right. The hedges formed a useful zigzag movement leading to the dark foil of the trees at the top.

Another key decision was how much foreground to include. I also wanted to ensure that the various parts of the composition linked together well. I slightly exaggerated the height of the tree in the centre-foreground to create a better link between this area and the cottages. The drawing took about 20 minutes, which included using making fluid to help define the shadow areas and to reserve some of the highlights in the tree on the left.

The first wash (stage 2, page 132) was a continuous, variegated one across the distant tree area at the top. Applied to dry paper, this wash included burnt sienna, French ultramarine, raw sienna, a little viridian, and then back to raw sienna. Next, moving down, I wetted the top edge of the hedgerow on the left, so that when I painted it, the outline wouldn't be too insistent. I used the same range of mixes for the buildings (mostly raw sienna, burnt sienna and French ultramarine), then I returned to the car to dry the painting with the small fan (as explained on page 89). I completed the front of the buildings with a raw sienna wash, which meant that the group of cottages was now more or less

View Above Dale House
28.5 x 39cm (11¼ x 15¼in)

Finally, a subtle warm wash was applied to parts of the background.

finished. Finally, I added a subtle graduated wash across the foreground tree and parts of the nearer hedgerows, to test how this area might be developed.

Once again I dried the painting with the fan, before starting on stage 3 (page 133), in which the main area of focus was the foreground. I needed to ensure that this part of the painting combined effectively with the buildings to create some 'weight' and interest. In fact it was a fairly nondescript, shrubby and overgrown area, so I had to use a bit of artistic licence to make something of it.

I added quite a strong transitional wash across the foreground hedgerow, using little spots of dark to suggest its form. Above it, the line of fence posts created a good link to the field boundary in front of the cottages, which was also placed with a variegated wash, as were the distant hedgerows. Now, the whole composition was beginning to come together.

Next, it was time to think about the shadows (stage 4, page 133). These not only provided a useful colour contrast but also an effective compositional device, linking the cottages with the surroundings and emphasizing the flowing movement through the painting. The shadows were painted with a mix of cobalt blue and cobalt violet, working from the base of the hedgerows outwards, using continuous horizontal strokes made with a No. 8 brush. Because I had left the masking fluid in place I did not have to worry too much about the light patches between the shadows. Thus I could confidently exploit the light against dark/dark against light effect.

If you look carefully at the final illustration in this demonstration sequence (stage 5, opposite) you will notice that I have applied a subtle warm wash across the lower parts of the snow-covered field, in fact making it slightly stronger in the nearer areas. This, I felt, added to the impression of the lowering winter light, and it further unified the painting. As in all paintings, one of the crucial factors was judging the right moment to stop. Had I done any more to this painting I think it would have started to lose that sense of a direct, individual response to the subject.

The Middle Way

This is the approach that I normally adopt outside – usually working on ¼ Imperial sheets of paper (either stretched Arches 640gsm [300lb] or sometimes paper from a Saunders watercolour block) and choosing subjects that have a degree of complexity but also involve some areas that can be treated in a more general way. If possible I want to produce a finished painting on site, although I may enhance some of the darks, for example, or make similar small adjustments when I reassess the painting later, back in the studio. My aim is to develop the idea much further than I would for a *plein-air* sketch, at the same time striving for an image that is well drawn and is painted in a loose, confident manner.

One of the first decisions for any painting is the composition format – does it work best vertically or horizontally? In Venice, as demonstrated in *Canal Moorings, Venice* (pages 136–138), ideas often suit a vertical shape. As well as the light and reflections, which are always inspiring qualities in Venice, part of the attraction of this subject was that, unusually for a Venetian canal scene, it included some greenery.

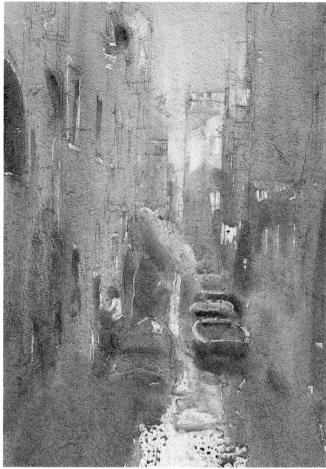

STAGE 1

Canal Moorings, Venice

The drawing, with most of the brightly lit foreground water protected with masking fluid.

STAGE 2

Canal Moorings, Venice

I applied the overall wet-into-wet variegated wash to establish the main lights and darks, and warm and cool areas.

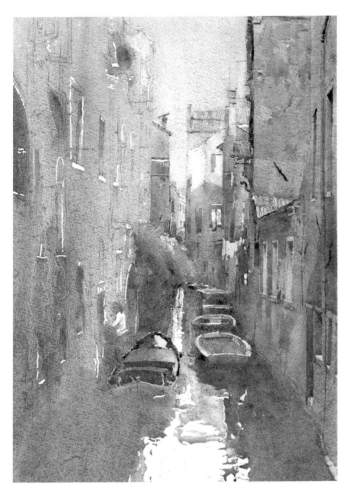

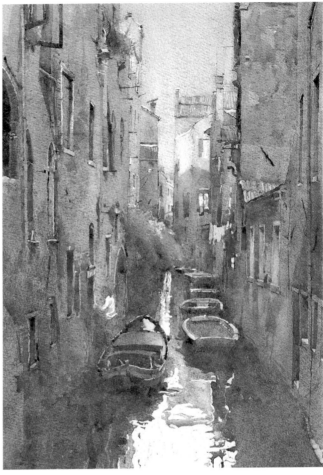

STAGE 3

Canal Moorings, Venice

The masking fluid was removed, to check the balance of lights and darks.

STAGE 4

Canal Moorings, Venice

Now I concentrated mainly on the central section to develop an indication of structure and form.

Page 138

STAGE 5

Canal Moorings, Venice
39 x 28.5cm (15¼ x 11¼in)

I used a rigger to pick out the darks on the left and create a better sense of balance and unity in the painting.

In the drawing (stage 1, page 136) I was careful to ensure that the focal point, beyond the boats, was set off-centre, thus placing more emphasis on the buildings to the left. I masked out various light areas that I wanted to preserve, including much of the foreground water. In fact, because this was such a large area, I applied the masking fluid with a split stick and my finger.

Next, I needed to make some colour decisions. I mixed washes of raw sienna, burnt sienna and cobalt blue, plus burnt sienna with French ultramarine for the extreme darks. For the crucial second stage (page 136) I had to work very quickly and intensely, using an overall variegated wet-into-wet wash to establish the general lights and darks, and warm and cool areas. Essentially, the left-hand side, most of which was in full light, was a warm tone, while the shadowy right-hand side was a much cooler tone. I did some additional work firming up the darks and the boat shapes, which I felt were critical to the impact and success of the painting.

To check the balance of lights and darks and their effectiveness, all I had to do for stage 3 (page 137) was to remove the masking fluid. Then I concentrated mainly on the central section (stage 4, page 137) to develop a better sense of structure and form. To achieve this I strengthened some of the darks, which helped to define shapes, and also to set the tonal key for the final stage 5 (opposite). I used a wash of cerulean blue plus a little cobalt violet for the water, making sure this related to the sky area. Most of the final brushmarks were made with a rigger, just to pick out the darks on the left and so create a sense of balance and unity in the painting.

The Considered Approach

Naturally, in the controlled conditions of the studio, the work undertaken can be far more ambitious, both in scale and content. *High Above the Old Town, Corfu* (pages 140–142) is what I would describe as an academic piece, an architectural study. While it is not particularly daring as a subject, it is nevertheless complex, and for this reason I felt that the best approach would be in the studio, where the method could be suitably structured, with the painting tackled in sections.

The reference material for this painting consisted of a sequence of photographs, plus some oil sketches and a small study in oils of the red tower, all of which were made on site. I use such material as a source of information rather than something that must be assiduously copied. As much as anything else, it helps prompt my memory and so enables me to recall the sights and feelings that I experienced when I was actually at the location. Obviously it is easier to recapture those experiences if the painting is started quite soon after returning from the location trip.

Because of the complicated nature of this subject, with its variety of buildings set at different angles and viewed from above, it was very important to make an accurate drawing (stage 1, page 140). This involved a lot of careful measuring to fix the relative position and scale of the buildings, and indeed a lot of rubbing out and redrawing! The secret with a complex scene like this is to start with the big shapes – the Roman Fort on the left, for example – and, having correctly placed these, relate the smaller shapes to them.

STAGE 2

High Above the Old Town, Corfu

The initial wash, keeping the background colour weak to accentuate the sense of distance.

The two key points that I decided to work from were the horizon and the red tower. Both of these are positioned more or less on the Golden Section proportion (see page 52). The other main decision was to concentrate most of the interest and detail in the foreground, contrasting this with the sort of background that I would typically include in one of my *plein-air* paintings – using a bold, loose treatment.

Planning the composition and making the drawing took me about a day and a half. The next step was to consider the lighting effect and, where necessary, block out the highlights with masking fluid to protect them from the initial 'ghost' wash. Again, this required a very focused approach, carefully painting the masking fluid on most of the walls and rooftops that faced towards the left.

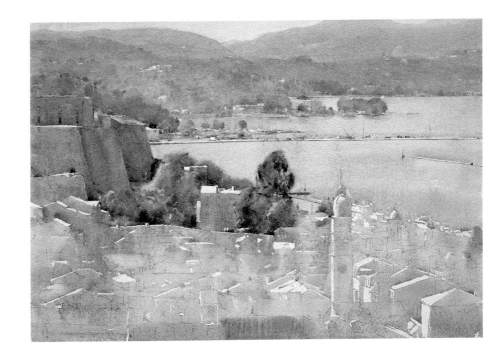

STAGE 3

High Above the Old Town, Corfu

By considering the degree of tonal strength and detail in the background, I established a reference for the rest of the painting.

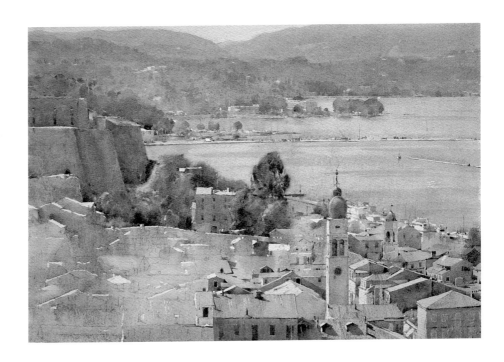

STAGE 4

High Above the Old Town, Corfu

Here I am concentrating on the right-hand foreground area.

I wanted to suggest a hazy quality of light in the distance, and consequently, when applying the initial wash (stage 2, page 140), I deliberately kept the background colour weak and subdued, contrasting the use of cobalt blue and cobalt violet in that area with warmer colours – such as raw sienna, light red and yellow ochre – in the foreground. As usual for me, this stage was intense and 'make or break'. Always the aim at this point is to set the course for all the important aspects of the painting – the mood, the tonal values, the colour harmonies and so on. The intensity and difficulty is all the greater when working on a big scale. Here, I used Nos. 12 and 14 sable brushes, starting at the top, painting wet-into-wet, and quickly flooding in the different colours as I worked downwards. The whole process took only about twenty minutes.

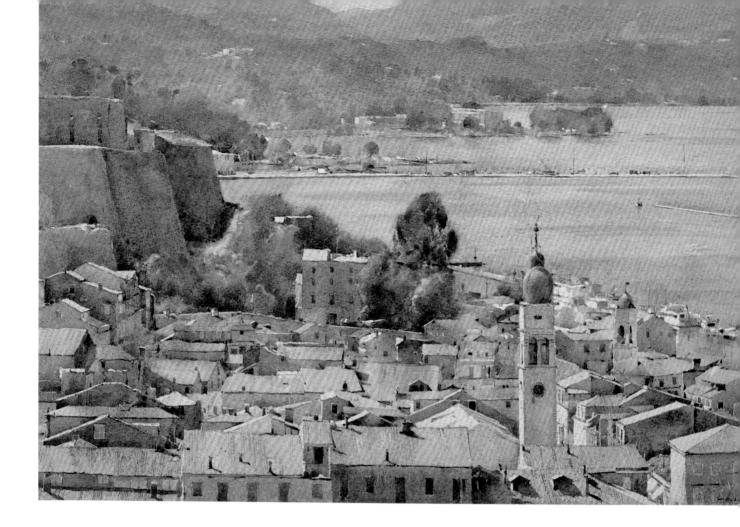

Next, I did some more work on the distant background area (stage 3, page 141). This in turn gave me a colour reference from which I could then judge the strength of colours to use in the rest of the painting. From this point on, although the washes were essentially still being applied wet-into-wet, the paint could dry slightly because the pace of work was slower, and thus allowed me greater control to produce more defined shapes.

Everything was now set for some considered painting in the foreground area. You can see from the final two stages that I have concentrated first on the area around the tower, on the right (stage 4, page 141) and then the opposite side (stage 5, above), subsequently removing the masking fluid and adding a few general brushmarks to bring the whole composition together. A big advantage of the 'Considered Approach' is that it is possible to work on separate areas, but of course you must always be thinking about how each area relates to the others and to the whole.

Always in a studio painting I keep in mind the qualities and effects that inspired me to make the original sketch and I try to imagine myself at the location, with its particular type of light and atmosphere. Although such paintings involve greater planning and complexity, I still want them to look as though they were produced *in situ*.

STAGE 5

High Above the Old Town, Corfu
39 x 57cm (15¼ x 22½in)

Finally I turned my attention to the left-hand side, to consider the overall balance of the composition.

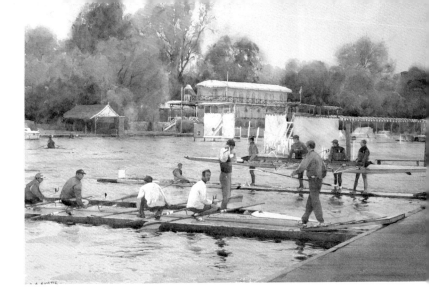

right *Qualifying Events, Henley*
39 x 57cm (15¼ x 22½in)

This painting incorporates many of the techniques discussed earlier in the book, including wet-into-wet washes, strong figure content, and exploiting a particular light effect.

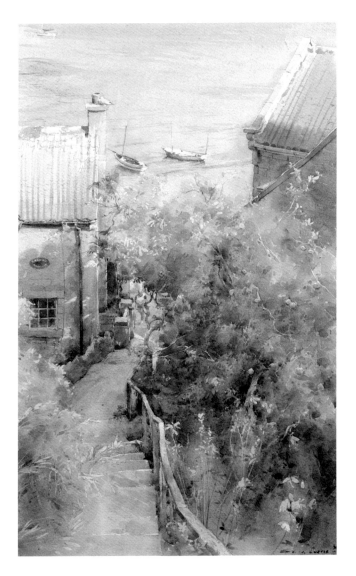

Steep Pathway to the Beach, Runswick Bay, Yorkshire
77.5 x 57cm (30½ x 22½in)

A stunning subject, just perfect for a large-scale watercolour painting!

Capturing the Moment

Virtually every painting included in this book was inspired by a *plein-air* subject, seen at a certain moment in time and therefore influenced by the prevalent conditions of light, weather, tide or viewpoint. Most of my subjects are transient. Something that attracted my attention in the early morning as a very exciting, dramatic view can seem quite different later on and may well alter even more by the following day. This is an aspect of *plein-air* painting that I particularly relish – that sense of urgency to capture the essence of a scene before the light, the colour, the mood and the impact of the composition begin to change.

Of course, painting outside is a high-risk business. As well as the practical considerations, there are many other important things to think about . You have to make decisions about the scale, content and composition of your painting, for example, the use of colour, and the sort of approaches and techniques that will best suit the way you want to interpret the subject. But these challenges are part of the attraction and enjoyment of painting, I think, and when everything works, it is immensely rewarding.

I hope that by explaining my working methods and sharing my thoughts and enthusiasm for *plein-air* painting, I have encouraged you to try this approach. Watercolour is the perfect medium – ideal for a sensitive, personal response, and for capturing the inspirational effect of light. I am a firm believer in the importance of drawing skills, sound composition, and respecting the characteristics of the watercolour medium – especially its fluidity and transparency. It takes time to achieve success, but when you do, the results are an absolute joy!

Index